IMAGES of America
ST. IGNACE CAR CULTURE

To:
Charlene,
My "Super" MO.
Thanks, Happy
Holidays!

12/12/07

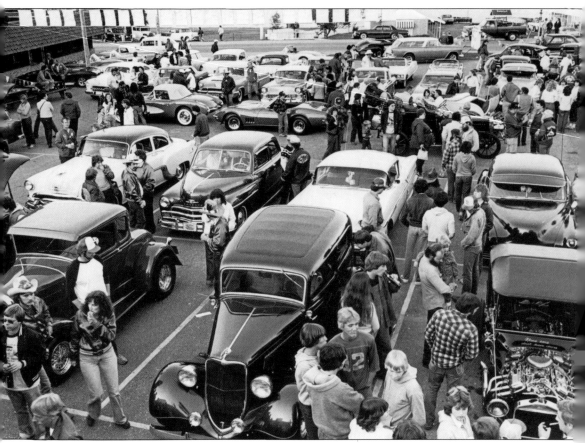

Cruising has been a big part of the car show weekend in St. Ignace from almost the very beginning. In the early years, Bootsie's Drive-In was the gathering spot. Since the cruise was open to the public, big traffic jams along North State Street developed on the Saturday night of the car show. Later, cruising expanded to two nights and centered around the Big Boy Restaurant, west on U.S. 2. For about a decade, cruisers enjoyed music played by live deejays on a stage there. The huge gridlocks and traffic-control issues eventually brought cruising back to one night only and on a prescribed one-way path that leads through downtown and out onto I-75, making a circle without an actual destination. Cruising was the way to spend many evenings for teens across the country in the 1950s and 1960s, but the practice is now banned in many places. But for a single night each year, St. Ignace steps back in time, and cruising remains an important part of the car show experience. (Author's collection.)

ON THE COVER: Through the early years of the 20th century, automobiles became more common and folks fancied the idea of travel off the beaten path. Many towns offered free campsites in their public municipal car parks. Private campgrounds and motor courts were the next step, and small cabins and cottages sprung up allover the country. In the 1920s, Edward A. and Lesta Reavie built the Silver Sands Resort, general store, filling station, and café on U.S. 2, five miles west of St. Ignace. Later their son and daughter-in-law, Kress and Elaine Reavie (parents the author), took over the businesses. The complex shown on the cover was located on the north side of the still-unpaved highway. The cottages were across the road on the shore of beautiful Lake Michigan. In 1923, the Michigan State Car Ferry system began transporting automobiles across the Straits of Mackinac. This made Michigan's Upper Peninsula—and Silver Sands Resort—accessible by automobile for the reasonable fare of $2.50 or $3.50, depending on the size of automobile. (Author's collection.)

IMAGES
of America

St. Ignace Car Culture

Edward K. Reavie

Copyright © 2010 by Edward K. Reavie
ISBN 978-0-7385-8439-3

Published by Arcadia Publishing
Charleston SC, Chicago IL, Portsmouth NH, San Francisco CA

Printed in the United States of America

Library of Congress Control Number: 2009943880

For all general information contact Arcadia Publishing at:
Telephone 843-853-2070
Fax 843-853-0044
E-mail sales@arcadiapublishing.com
For customer service and orders:
Toll-Free 1-888-313-2665

Visit us on the Internet at www.arcadiapublishing.com

*This book is fondly dedicated to my son, Sean E. Reavie;
he followed the long and winding road to his dream.*

Contents

Acknowledgments		6
Introduction		7
1.	Local Heroes	9
2.	Car Show . . . in St. Ignace?	41
3.	California Dreamin'	71
4.	The VIPs	85
5.	Still No Traffic Light!	109

Acknowledgments

To all who joined me or were a part of this lifetime journey, thank you! The photographs are from the author's collection except when noted.

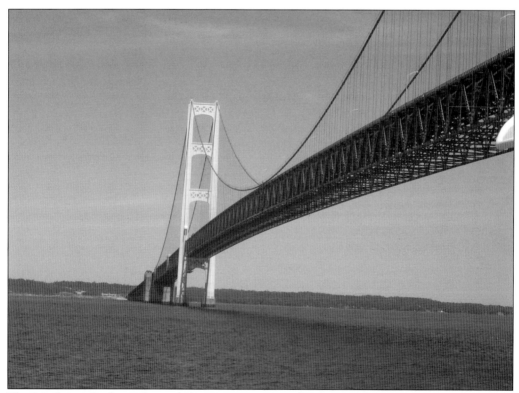

The Mackinac Bridge, a five-mile-long span crossing the Great Lakes between St. Ignace and Mackinaw City, opened on November 1, 1957. Previously ferries had transported passengers, freight, and automobiles over the Straits of Mackinac. Formerly known as the "Gateway City" (of Michigan's Upper Peninsula), St. Ignace recently welcomed the 150-millionth vehicle crossing over the Mighty Mac, a milestone due in part to car show attendance. (Eileen Evers.)

INTRODUCTION

In 1975, the U.S. bicentennial was on the horizon, and most towns and cities were planning some sort of a celebration—St. Ignace was no exception. A small group of citizens came upon the idea of a one-year-only car show for the summer of 1976. Edward K. Reavie, a local banker, was tapped to put the details in place. For his entire life, Ed had been a gearhead. At five years old, he found a way to have wheels; at seven, he could name the make, model, and year of almost every car he saw.

In the late 1940s and on into the 1950s, big things were happening on the sunny West Coast: hot rods and radical customs, auto shows, car clubs, organized racing, and car magazines. The East Coast had the same things on a smaller scale, but St. Ignace was far off the beaten path and not even on the same radar screen being 300 miles north of the Motor City. The local teens were on the outside looking in. Oh, they could cruise, they could soak up the rebellious anthems of rock 'n' roll, they could lay a patch in town or head out to Miller's Stretch to come off the line, and they could send mail orders for parts and tinker in the backyard, but it always seemed as if next month they were waiting for the snow to melt, *again*! The true gearheads held on to their fascination with cars, and nothing could make them let go.

As in all endeavors, customizing has developed its own lingo. What in the world is nosing and decking? A mild customization starts with the removal of chrome from the hood and trunk deck; thus nosing bares a hood, and decking clears a trunk. Of course, this is just the beginning. The sky is the limit when determining how much more drastic it can get.

Though it would return to popularity, for a time the custom car faded and the muscle car took over the road. St. Ignace had its share of these, including GTOs, Corvettes, SS 396s, and six-pack Road Runners. Then along came the St. Ignace Car Show. Over the years, the biggest names in the automotive industry came to town to be part of this world-renowned event, and Ed still does not realize that his heroes consider him a peer. Movie stars, television personalities, and nationally known musical acts were added to complement the show as icing on the cake.

The show attracts visitors from near and far. In fact, the farther away one goes, the St. Ignace Car Show name gets shorter and shorter. For example, way out west it is simply called "Ignace." Folks come to the show to see beautiful cars, enjoy the picturesque waterfront and Mackinac Bridge Rallies, or just for the fact that all collector vehicles are welcome—from an all-original, 110-year-old horseless carriage to a hybrid purchased just last week. A person may see a 1927 Rolls Royce parked between a wildly customized 1951 Merc and a rough-looking 1909 Cadillac that was just unearthed from Old MacDonald's barn. The diversity of this show inspires one to become more flexible about just what is *the one and only great car*.

St. Ignace has seen over three centuries of booms and busts, and the St. Ignace Car Show turned out to be a big boom. For the first show, exhibitors were encouraged to attend by the offer of a complimentary bridge fare. Organizers were pleased by the unexpected and overwhelmingly positive response from both spectators and exhibitors. Who knew that a small, remote town in

the Upper Peninsula of Michigan could be such a good fit for a show on the big car show map? The consensus seemed to be that "this worked so well . . . let's try it just one more year. Didn't *you* have fun?" With a longtime reputation of well-run events, Ed Reavie is still at the wheel 34 years later. There have been tweaks and adjustments, successes and backfires, triumphs and fizzles, breakdowns and repairs, misfires and flourishes, and hits and misses through the years, but the show goes on. It goes on because Ed's car show formula is a natural; he runs the show the way he runs his life—with integrity. Come to the car show next June to reawaken memories of a first automobile, and she may be parked just around the corner at the curb on State Street.

Ed would never say this out loud, but he suspects that the "ride of his life" is all a dream from which he will awaken. He often mentions that a car has "just the right stance," and those who know him declare that he is "just the right guy" to run this stellar show. Ed has said, "The car show presented an opportunity to meet our heroes . . . and we were never disappointed."

—Judy Gross and Eileen Evers

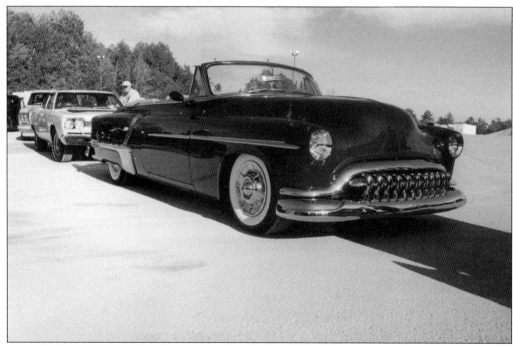

It isn't hard to imagine cruising—top down—in this wine 1953 Oldsmobile. The nosed and decked sleekness, added to just the right stance, makes this car very attractive. Frenched headlights and DeSoto grill teeth with a modified front bumper give an elegant forward presentation. The addition of a set of nice pipes makes this is a well-put-together custom.

One
LOCAL HEROES

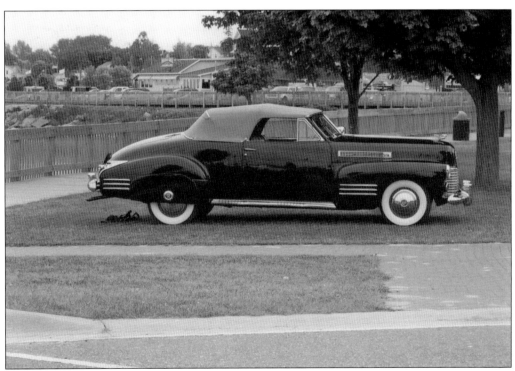

Glossy black body paint, tan top, and elegant lines give this 1941 Cadillac a stately grandeur. Its accouterments—chrome rocker panels and "The Goddess" hood ornament—solidify its overall good looks. Red wheels and red Cadillac medallions centered in the fender skirts provide just a touch of whimsy.

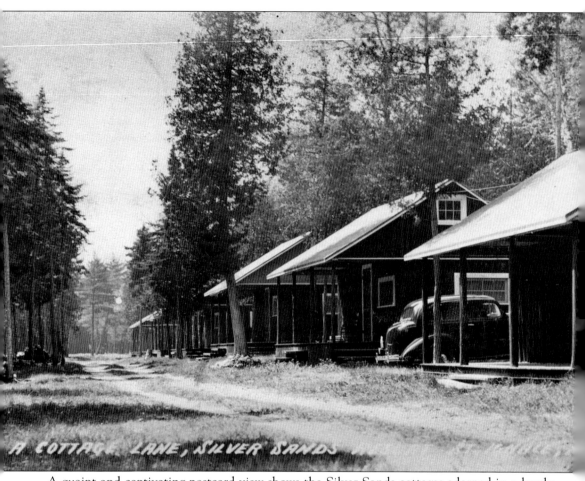

A quaint and captivating postcard view shows the Silver Sands cottages adorned in a lovely Christmas card–like dusting of light snow. Each summer, Ed Reavie's whole family moved out to Silver Sands Resort from their Marley Street home to take care of vacationers and the motoring public. Young Ed was expected to pull his weight through the summer. He cut grass, whitewashed the driveway rocks, stained and varnished the 14 cabins each year, and took care of the outhouses daily. Though the buildings on the north side of U.S. 2 (see front cover) are long gone, the cottages remain and are still a popular vacation spot.

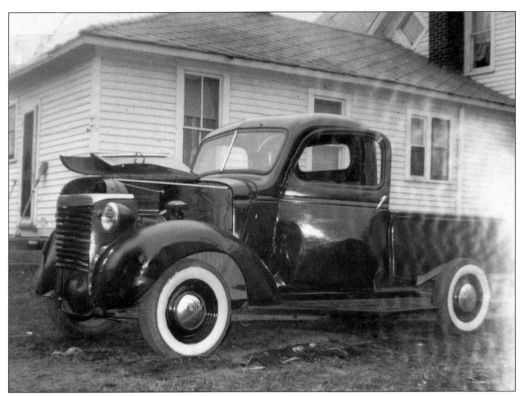

This sturdy 1940 Chevrolet pickup became the workhorse for the Silver Sands businesses. By age 12, Ed was tooling around the resort picking up the garbage. Later he removed the front fenders and hand-painted the rims red and the body shiny black. Kress kept this reliable truck for over 20 years until he sold the resort.

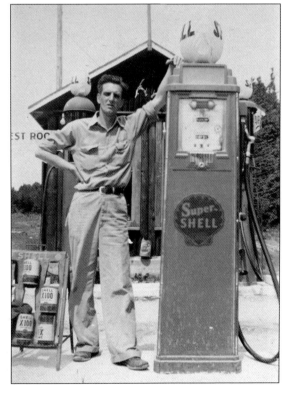

Ed's father, Kress Reavie, stands ready to "fill 'er up" at the Silver Sands gas station. This was a very basic filling station, typical of its time. Offering oil and free air for tires, the car's windshield would be cleaned and the oil level checked. The attendant would pump the gasoline—and it was just 13.9¢ per gallon.

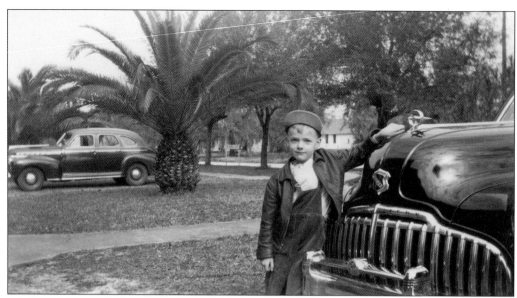

Ed's love affair with all things automotive had early beginnings. He just could not stay away from any available car. A family friend's 1946 Buick gets a hug in this photograph taken on an early family vacation to Florida.

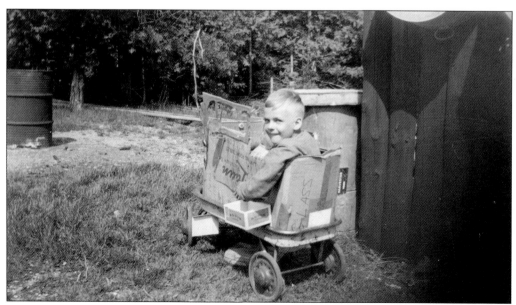

Ed was way too young to drive a real car, but not too young to have "wheels." He test-drives one of his very early creations. By age six or seven, he could tell the year, make, and model of any car he saw.

Ed was bored with school, and he didn't fish, hunt, or play sports. He amused himself by drawing cars and looking at automobile ads in magazines. In 1949, at age nine, he was standing at a counter in LaRocque's Drug Store (above, mid-left, see Rexall sign) looking through the comic book section with a quarter in his hand. Looking up, he spotted a very large magazine called *Motor Trend*. It was the first issue and inside were several photographs of something called Barris Kustoms—he was hooked. To think of buying two comics and a candy bar was nothing compared to having this wonderful magazine (at right). He still has this *Motor Trend*, and George Barris and Sam Barris's son, John, are his personal friends.

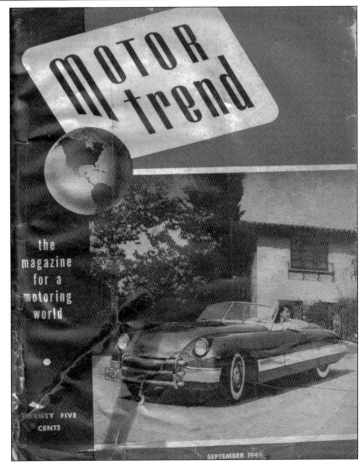

Ed was like many youngsters fidgeting through church services. Local Chevrolet dealer and friend of the family Ray McLachlan took pity on the little kid. He brought some brand-new automobile dealer brochures to church for young Ed to read. This kept Ed occupied and helped to sustain and further his interest in cars. (Floyd Joliet.)

As time passed, Ed's cars became more sophisticated. These three automotive engineers, hard at work on their orange-crate specials are, from left to right, Frank North, Ed, and "Little Doc." Note that Ed's car (center) shows signs of customizing: windshield, radiator cap, antenna, and coffee-cup headlights. A porch at Silver Sands Resort became a good substitute for a garage in this September 1952 photograph.

Nine-year-old Ed has imagined his fantasy car . . . and here it is. At first it is only heard, the dual Smithy's (muffler) backing off as it travels toward Silver Sands Resort, before it is seen. Don Clark had driven north from Ypsilanti in his maize-yellow, lowered 1947 Ford, customized with skirts, spotlights, spinner caps, and dual pipes with echo cans. Every time Don started the flathead V-8, Ed ran to the door to hear it better. Surely Don never realized how he inspired Ed with his dream-come-true car. Pictured here is not Don's car, which is long gone, but a very similar example except for the wheel covers. Richard Deming of Hastings, Michigan, brought this spectacular Ford to the 2007 show and gave permission to use it to tell this story. Nostalgia accounts executive Cindy Taylor stands with Deming's Ford.

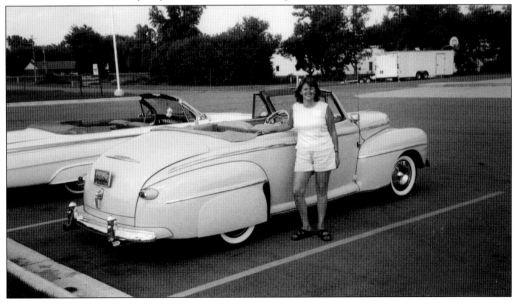

Ed went to Lincoln Park to visit his 16-year-old cousin, Mike Eldridge, in late 1954. Uncle Elmer had just purchased a 1955 small-block 265 Chevrolet Bel Air. On this momentous trip, Ed was bombarded with firsts: first ride in a 1955 Chevy, first stoplight drag racing (on Fort Street), first drive-in restaurant cruising, first high-power deejays, and his first pizza. Ed came home a different person.

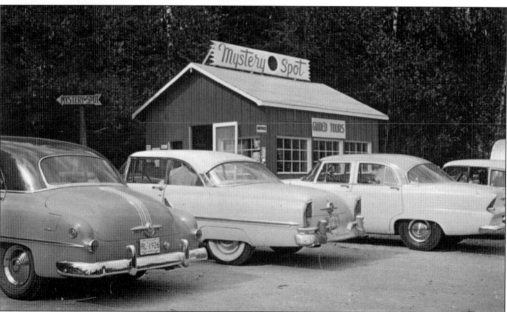

Fred Nelson, Velden McCray, and Clarence Manschereck built the Mystery Spot in 1955–1956, about five miles west of town. They used old furnishings borrowed from Silver Sands Resort. This 1957 photograph shows the beginnings; other buildings were added later. In those early days, every car had a paper placard advertising the Mystery Spot wired onto its rear bumper before it left the parking lot. (L. L. Cook.)

Lester "Sonny" McLachlan was always a car guy. His 1952 ivory over blue Ford Victoria Crestliner (above) was replaced in August 1955 with the new solid-blue Ford convertible (below), fondly called *The Blue Streak*. Dr. McLachlan advanced to high-performance, drag-racing Mustangs and then on to Rolls Royce and Ferrari and a Cigarette racing boat. He now cruises in a Shelby Super Snake Mustang. (Both Dr. Lester McLachlan.)

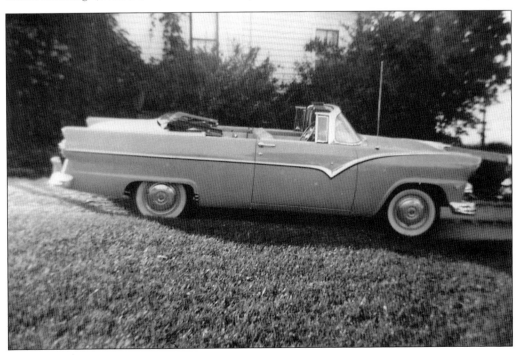

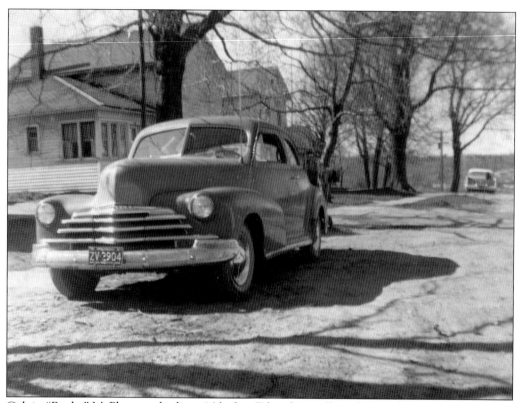

Calvin "Bucky" McPhee reached age 16 before Ed and was allowed to use his parents' two-door, burgundy 1954 Chevrolet 150. It wasn't their car of choice, by a long shot, but it was available and it allowed them to cruise. St. Ignace was as far away from both the East and West Coast car culture as one could get. Winters were severe, and everything had to be ordered when they could manage to save a few bucks to buy bits and pieces. This presented a real challenge in keeping their automotive devotion alive. Bucky got his own car first, a gray 1947 Chevy coupe (above), which he promptly nosed and decked. He added skirts and Y-job dual pipes. Bucky created his own spinner caps (below) by bolting metal shoehorns to the hubcaps. (Below, Eileen Evers.)

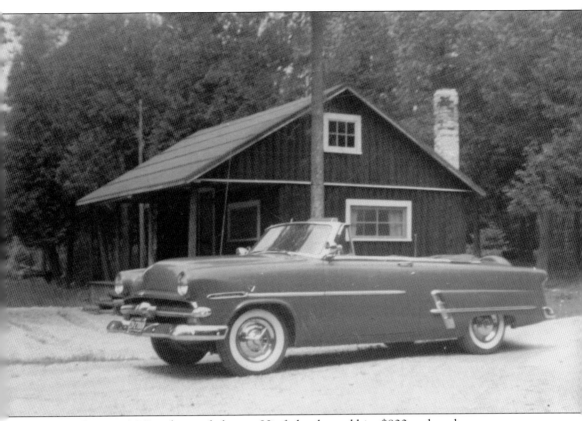

Ed was working at A&P, so he needed a car. His father loaned him $800 and made up a coupon book for monthly payments. The fifth-hand, red 1953 Ford convertible was a very cool car for a tenth grader. Once it was his, though, he began work on it: nosing, decking, frenching in Oldsmobile taillights, removing the bumper guard, modifying the grill, and adding Oldsmobile spinners and dual spotlights; but first, the Coronado Deck (fake continental kit) had to go. The interior was beautiful in red and black leather with a magnificent black instrument panel. He also had the first Bermuda "Ding-Dong" Bell and the first electric trunk in town. The car was then lowered. One day his father asked to trade cars, saying he wanted to drive a convertible. When the Ford was returned, it had dual pipes. He had gotten the exhaust changed to dual glasspacks with chrome extensions. Ed was also able to buy a set of bubble fender skirts for $50. They really added to the overall look of this nice car.

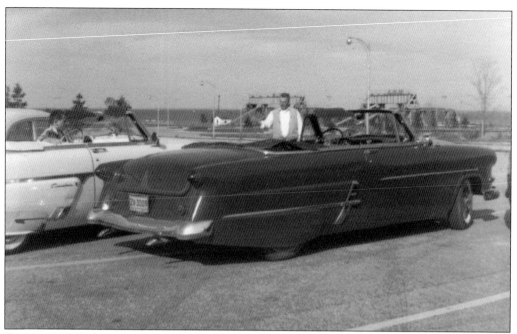

On May 4, 1956, the magic day arrived, and Ed was first in line at the Mackinac County Courthouse to take his driving test. His beautiful, red 1953 Ford convertible was his test car. Of course, the test was a piece of cake, and he passed with flying colors; he had been practicing for several years—off the road.

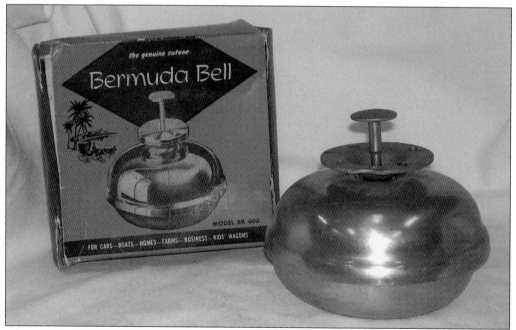

Ed tricked up his first car with this Bermuda "Ding-Dong" Bell, later moving it to his second car as well. Mounted beneath the floor, the plunger protruded above the floorboard and could be activated by a tap of the driver's foot. The Sutone Corporation in Los Angeles, which also made and sold curb feelers, manufactured the bell. (Eileen Evers.)

Bob Blair was another guy who always had a custom. His nice 1955 Mercury was de-chromed and lowered about as far as it would go (by Wayne Johnston), with lake pipes and other touches. In the 1960 photograph above, Bob's Mercury is flanked by Ed's 1953 Ford convertible at the Blair family's motel. In the photograph at right, Bob is touching up the Mercury's tires at Silver Sands Resort in 1962. The popular lakeside resort was a great spot for all the local guys to check out the female clientele.

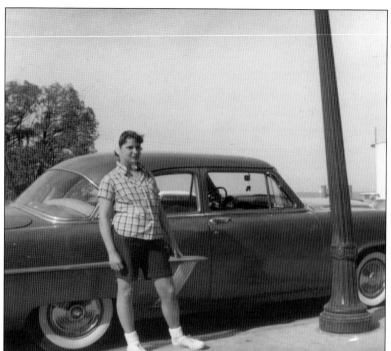

Albert Mundt worked as a mechanic at the local Ford dealer and owned this pretty, blue 1952 Mercury two door. It was nosed and decked with mellow-sounding duals. He loved to have his radio turned up loud when he cruised, and he played a harmonica at the same time. His favorite was Guy Mitchell's "Singin' the Blues." An unidentified admirer stands by the sedan. (Albert Mundt.)

Don Vallier's family left for California after his dad died. Driving the family's 1953 Chevrolet, Don returned here to graduate, but some changes had occurred: Don's hair was bleached blond; the Chevy was raked, nosed, decked, and painted bronze; and it had real screw-on moon discs, lake and side pipes, furry angora dice (the first ever in St. Ignace), dual exhaust, and a split manifold that gave it a nasty sound.

Don took his nice 1953 Chevrolet back to California. By the time he returned to Michigan the next year, the 1953 coupe had expired, and he now drove a 1955 Chevrolet. But his was not just another car; it was a magnificent vision that opened everyone's eyes to great possibilities. The white convertible was scalloped in turquoise with a Tijuana tuck and roll interior complete with a turquoise diamond-patterned, tonneau-covered backseat. The Corvette engine was complemented by a stick-overdrive combo and full-length lake pipes. With a modified grill and 'Vette wheel covers, it also had the usual nose and deck job with a radical lowering, front and rear. It blew the local guys away. Don left St. Ignace in the winter of 1961 and did not return for over 30 years.

Don Liggett's blue over ivory 1954 Ford Victoria V-8 with dual steel packs had an incredible set of pipes. Sometimes he would creep quietly into the campground and back up until the tailpipes were just touching a tent's canvas. Slipping it into neutral, he would floor it, allowing those wonderful pipes to rack off with a sound that could be heard for miles. Don would leave with his headlights off.

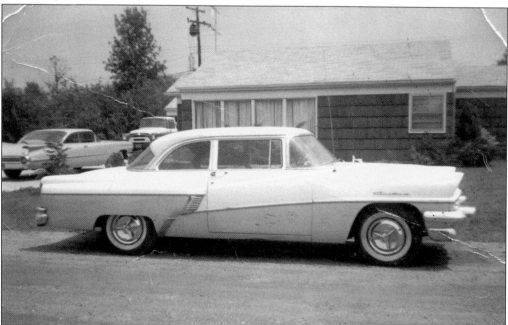

Darwin Humphrey was a city kid whose family transplanted to St. Ignace in 1956. With his all-black clothes, motorcycle boots, ducktail, and cigarette pack rolled into his T-shirt sleeve, he could have been one of the guys in the movie *Blackboard Jungle*. His car was a light-blue and white 1956 Mercury. In 1958, he left St. Ignace and joined the military.

By this time, Bucky had his second car, a white 1954 Ford convertible. This low-mileage beauty had the new OHV V-8 with great-sounding exhaust. He nosed and decked the car and added Oldsmobile lights, spinners (real ones this time), and skirts. This October 1958 photograph shows a partial decking in the works.

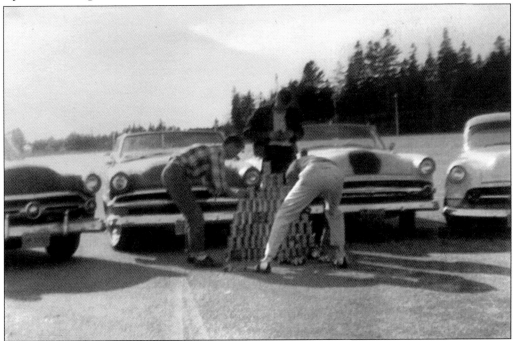

Building a post-party beer can pyramid on Dock Three are, from left to right, Eugene Sweeney, Ed, and Bucky. Lined up behind them are, from left to right, Eugene's 1952 Ford, Ed's 1953 Ford, Bucky's 1954 Ford, and Donald Vallier's 1953 Chevy.

Duane Stokes drove this beauty, a red and white 1956 Mercury with bubble skirts, Oldsmobile spinners, and a little drop in the back. He graduated to an all-black Charger R/T and then to a rare, solid-black GTO Judge with ram air. Later Duane judged Ed's car shows and drove a 1995 Mustang Cobra and a 1995 Mustang GT, the fastest cars in town at that time.

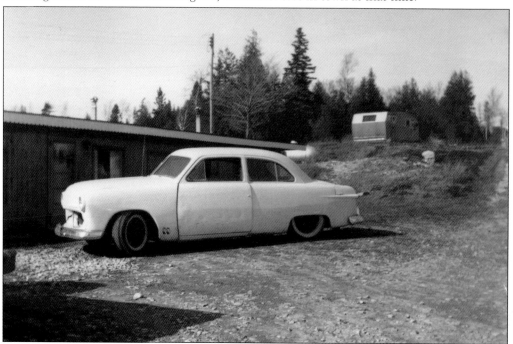

Every town had a kid called "Sputnik" during the late 1950s. Kenny Gust was St. Ignace's, and he was very bright. Kenny was another low-buck hobbyist, and he had a lot of fun in his slammed shoebox Ford (shown in May 1961).

Ed's second car was a 1956 Peacock Blue Ford Victoria called *Little Star*. It had a four-barrel Thunderbird engine, dual exhaust, three-speed with overdrive, a modified grill, and 1959 Buick taillights. Being radically lowered with functional full-length side pipes, it was a great cruiser. All the bodywork was done by Stanley Younts, who had a two-car body shop near Ed's home.

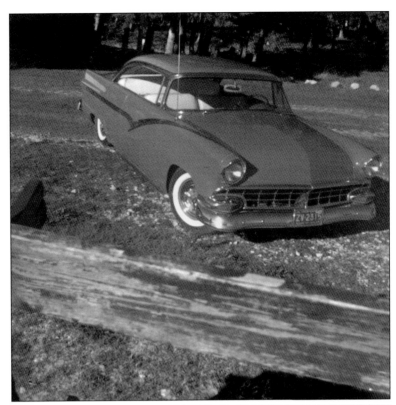

Another serious car guy was Vern Erskine from Moran. The rare (to the area) sportsman green and black 1951 Ford Crestliner was designed by Gordon Buehrig, a past St. Ignace Car Show guest of honor. Erskine traded in the 1951 to purchase his new 1953 Ford convertible, which was later Ed's.

St. Ignace's main drive-in restaurant was Chief's Drive-In. The Reavie family sometimes went there in the 1940s, when the parking lot was still gravel. By the mid-1950s, the lot was blacktopped and a large neon sign had been installed near the road. The local teenagers cruised this drive-in every day and night, waiting for a vacant spot in the back two rows. These were prime spots at night, under the glow of the neon that reflected off the freshly waxed paint. In the 1956 photograph below, the tray return area is under the umbrella. This gave the cars a turnaround and a short straightaway to accelerate and back off the pipes before they had to stop to enter State Street heading back toward town.

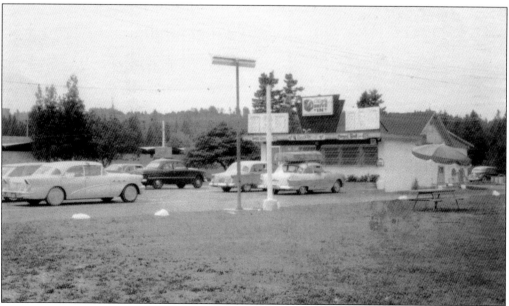

Lou and Dorothy King (shown with Ed at center) owned Chief's Drive-In until the mid-1960s. Later they managed several motels, including St. Ignace Car Show's first host motel, Chalet North. They worked on every car show through 1994 and now live in Las Vegas. They played a major part in all the local teens' lives, as the kids spent more time with them than with their own parents.

In the 1950s, another attraction was the Tugboat Drive-In, right across from Chief's. It was unique because it was a real tugboat. With inside or outside service, in the summer there was a local rock band or deejay providing music on the roof. Another drive-in was the Bark and Suds, about three miles out on U.S. 2. Its gravel parking lot kept it from really catching on.

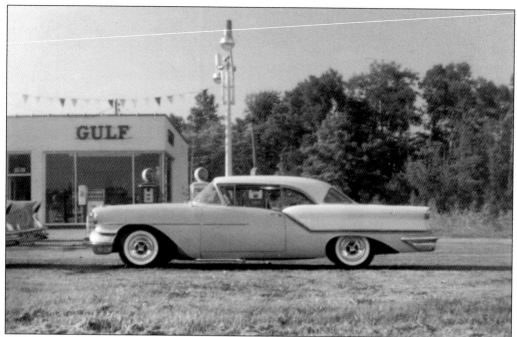

Bucky had the fastest car in town. With eight cylinders and a four barrel, his light-blue and white 1957 Oldsmobile Super 88 Holiday hardtop, called *Wild One*, would blow the doors off a power-pack Chevy. Bucky's Olds had mild custom touches, and the beautiful instrument panel looked like a jukebox. It had Dodge Lancer spinners and dual glasspacks and was nosed, decked, and lowered with the horizontal grill bar removed.

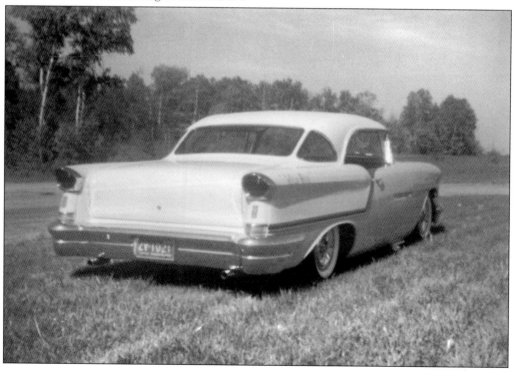

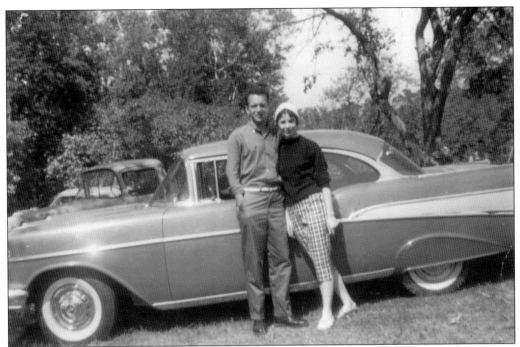

Alfred "Junior" Branham and Patti Dory stand with his Matador Red 1957 Chevrolet Bel Air sport coupe with fender skirts and GM spinners in 1958. He and his brothers all had new cars and basically changed cars every year. These were always top-of-the-line special cars. (Alfred Branham.)

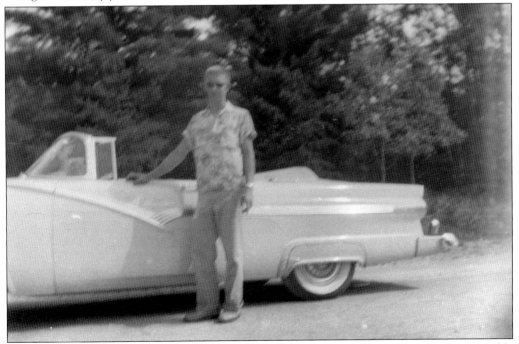

A Carp River heavy hitter, Gerald "Skip" Wiggins bought this baby-blue 1956 Ford convertible brand new with factory wire caps, Thunderbird V-8 engine, and continental kit. The white convertible top had custom snaps on its boot to dress up that sleek, long rear deck.

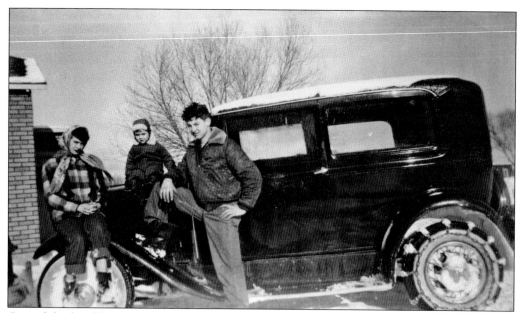

One of the local heroes was Wayne Johnston. He lived north of town in the Carp River area. His first car was a 1930 Ford Model A sedan. His father, Elmer, gave it to him when he turned 14 in 1950. Wayne stands at right with his sister Shirley and brother Donald. Check out the chains on those whitewall tires.

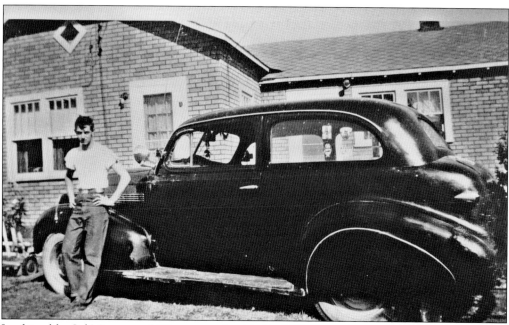

Looking like Sal Mineo, cool Wayne stands with his 1939 Chevrolet two door. After paying $50 and spending a few dollars more on it, he had a great car. Wayne worked at the Phillips 66 gas station for a while. There he had access to a cutting torch that he used to drop the front coils on all the local cars to get them down to the ground.

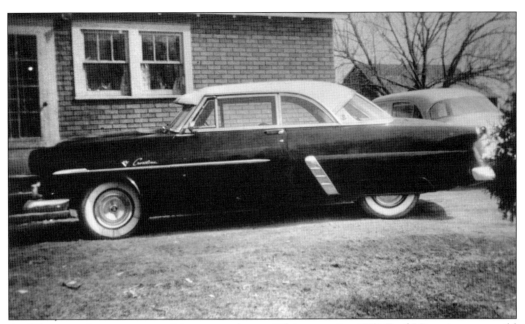

As Wayne made more money, his cars got better. This very nice 1952 Ford Victoria was a mild custom with skirts, Buick spinners, a sun visor, whitewalls, and dual glasspacks. The cream over black body paint gave it a simple splendor.

Wayne stepped up to a beautiful yellow and green 1954 Bel Air two-door sport coupe. He kept most of its factory trim, plus bloomers (the chrome trim on the skirts that continues along the bottom of the rear fenders behind the gravel guards). The high point of this car, however, was the sound. The split manifold with steel packs would rattle windows for blocks.

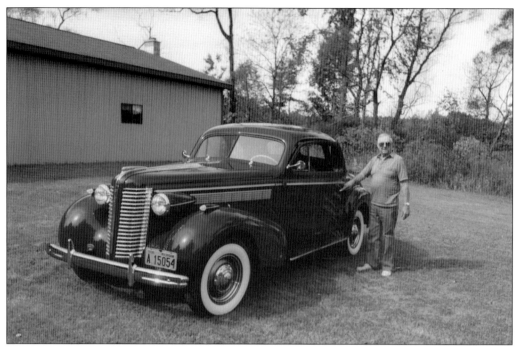

Now Wayne enjoys cruising and showing this 1938 Buick coupe, and he has antique farm tractors to keep him busy. He has also acquired an attractive collection of Michigan license plates. Just recently, he finished a long-term Model A restoration.

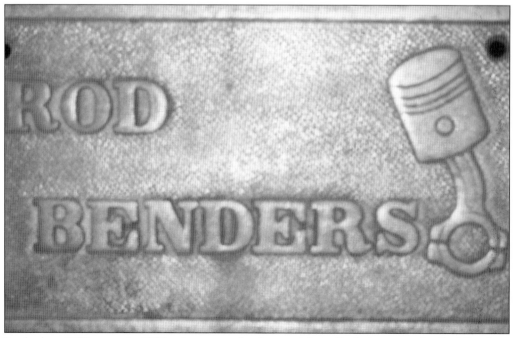

In the late 1950s to early 1960s, the one and only car club in St. Ignace was the Rod Benders. Members displayed their metal plaque in the back window or under the back bumper.

The purchase of one's first new car is always a memorable experience. Bucky was parts manager for Mahoney Motors, and he and Ed both ordered 1961 Chevrolet Impala hardtops that fall. Bucky's was Fawn Beige; Ed chose Midnight Blue (shown in both photographs; no pictures of Bucky's exist). Both were power-pack, stick, and overdrive equipped, and they were very quick. They both wanted to be the fastest, but overall, Bucky's claimed that title. Ed took his car directly from the dealership and installed dual glasspacks and long scavenger pipes. Next stop was Younts Body Shop for removal of all chrome and a taillight change. The car had four bar spinners and looked great with only seven miles on it. Not to be outdone, Bucky nosed and decked his, rerouted the tailpipes, and added spinners and glasspacks.

By 1965, Bucky was driving a green 1965 Chevy Impala Super Sport 396 four speed, and Ed was tired of playing second fiddle. Ed secretly ordered a new four-barrel, four-speed 1965 Pontiac GTO 389 with positraction in Nightwatch Blue. It was a long six-week wait, and by the time the dealer called, Ed had worked himself into such a frenzy that he was sick in bed. He felt better once he got his hands on the car, and then it was time to go hunting. Bucky turned "a whiter shade of pale" when he saw that sinister grill and GTO nameplate in his rearview mirror. They raced from a dead start, a rolling start, and with a 100-mile-per-hour running start. The Chevy was whipped. This GTO (below) settled all arguments about the fastest car.

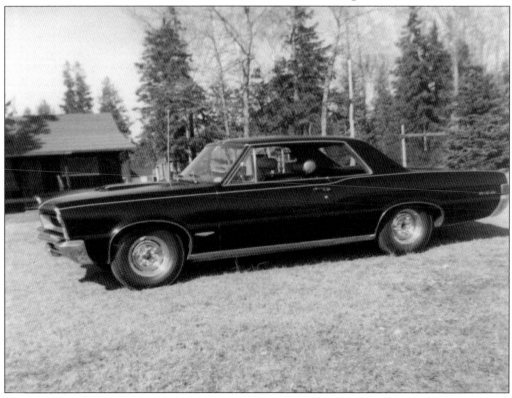

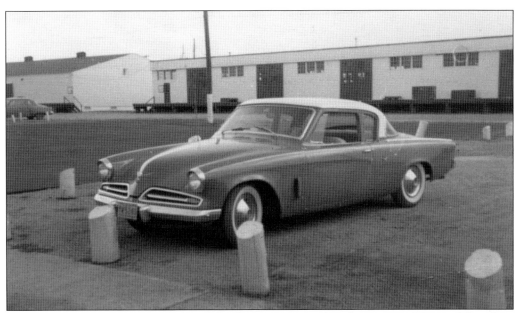

Gerry Black's 1953 Studebaker (above) displays stunning styling by Raymond Loewy. The white over red coupe had a gray interior and a 232 V-8. These basic body lines were used for Studebaker's Hawk series through the 1964 model year. The 1953 coupe was acclaimed numerous times as the most beautiful car ever built. In 1963, Gerry bought a new Studebaker Avanti (below). Never a commonly seen automobile, his was one of only two in St. Ignace. White with an orange vinyl interior and a fiberglass body, the car was equipped with the 289 four barrel, an R-2 blower, duals, and an automatic transmission. This car, too, was a Loewy creation. He designed a potpourri of diverse everyday items: Bulova watches, locomotives, Lucky Strike cigarette packaging, the round Coke bottle, and Greyhound buses, to name a few. (Both, Gerry Black.)

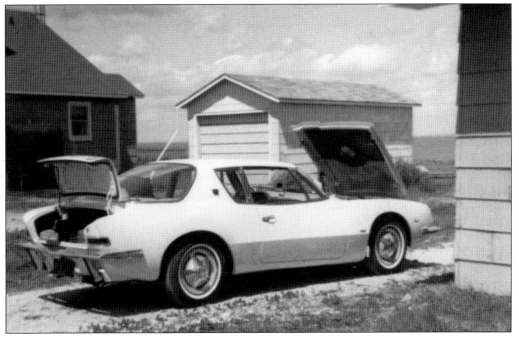

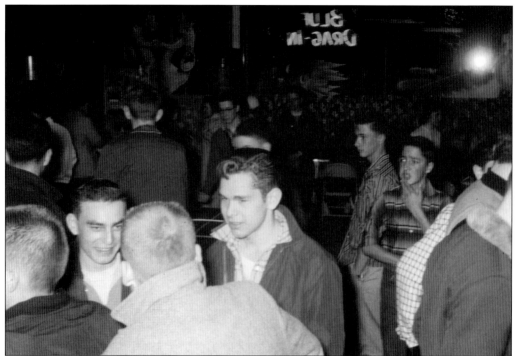

A 1958 photograph shows the crowd at the Blue Drag-In teen center on State Street in St. Ignace, managed by Pete and Isabel Simmons. This popular spot had a jukebox, a pool table, a big parking lot, a hamburger-type menu, and a late closing time. It had a large dance floor with seating all around that enabled the local youth to check out the action.

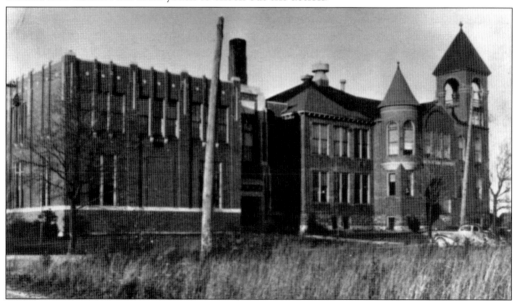

Almost everyone mentioned in this chapter attended the local LaSalle High School. The class of 1962 was the last to graduate from this building. The Knights of Columbus purchased it, and the right side was demolished to provide additional parking. The new high school was built farther out of town to the west. (Views of the Past.)

Peter Males's parents brought him to St. Ignace in about 1960 and built the first super motel on North State Street. Peter had a succession of very cool cars. One of them was a magnificent Nocturne Blue Pontiac Grand Prix. His car had the Royal Pontiac Bobcat package, ruling the streets with a 421 four speed with three deuces. This rocket was scary even when it was parked.

All the 1940s- and 1950s-era high school guys wanted one of these: a black 1940 Ford, lowered, with fender skirts, dual spots, chrome running boards, and great pipes. Who could blame them? The flathead V-8s were produced in huge numbers. A full line of model offerings gave ample opportunities to purchasers who wanted a sleek automobile that really didn't need much customizing. (Joe Joliet.)

From its huge chrome grill to the factory Continental kit on its chrome bumper deck, this Ford is sublime. The glossy paint—red over black over red with a gold swoosh—is absolutely stunning. The Fairlane Skyliner retractable roof and long rear deck gave this eye-catching car a number of different looks. The interceptor four barrel with duals made it sound outstanding. (Joe Joliet.)

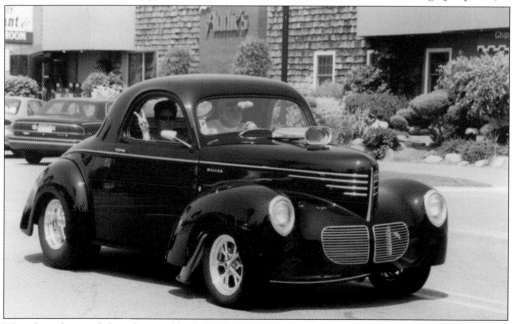

The clean lines of this elegant black Willys Americoupe look quick even before one can spot the chrome blower scoop and the dumps (headers in the front wheel wells). The stock body has a red interior.

Two

A Car Show . . . in St. Ignace?

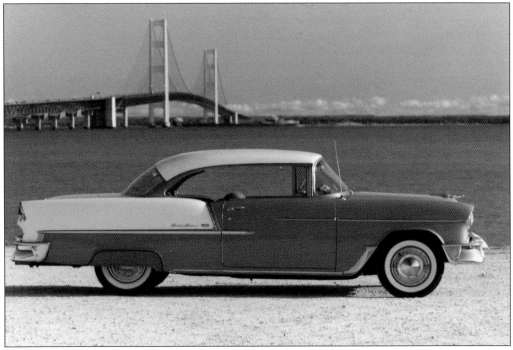

Here are a flawless pair of venerated icons—both over half a century old and getting better every year. The timeless styling of the 1955 Chevrolet is an eye magnet wherever it goes. It revolutionized automotive design in an exciting way. The magnificent Mackinac Bridge, "the bridge that couldn't be built," is graceful and compelling. Each is an engineering marvel in its own way. (Photography By Ron.)

A group of St. Ignace citizens met to discuss the possibilities for a bicentennial celebration. Present were city manager Jack Goll, his secretary Ruby Goudreau, WIDG radio station manager Don Angelo, newspaper reporter Greg Means, and Ed Reavie. Ed suggested a one-time car show and agreed to head it up. Car owners were offered Mackinac Bridge fare and gas money amounting to about $5 and no entry fee. Each entrant was also awarded a plaque made by the high school shop class. A pre-registration of 116 vehicles grew to 132 actual entries. The city set the show on Dock Two the last Saturday of June 1976 and assigned seven auxiliary officers to show-day duty. Winners were chosen in five divisions: antique, classic, special interest, people's choice, and longest distance driven. Lodging rates for that show were $16.64 for two people. Attendance was estimated at 5,500, and many of the cars paraded past the Mackinac Straits Hospital's long-term care facility so the residents could enjoy them. Here is a later show, stretching almost two miles along State Street.

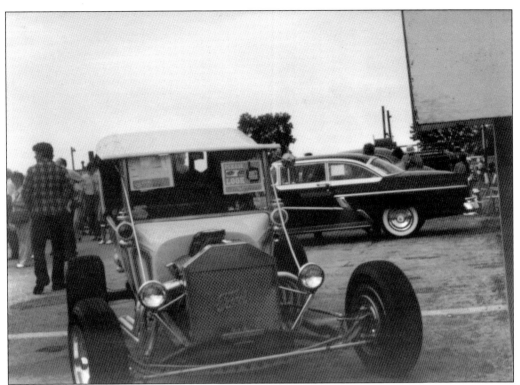

In the foreground is Bob King's 1926 T-Bucket. Behind is a 1956 black and white Mercury Montclair two-door hardtop. This car was owned by Crusoe-Nunley Ford in Cheboygan, Michigan, and was the first official entry in the initial 1976 St. Ignace Car Show. Later the Merc was crushed when the roof of its storage building was caved in by heavy snow.

Bob King's 1926 T-Bucket was a real cruiser. This powerhouse street rod was a combination of 20 different automobiles, including a Corvette engine. It had been featured in a 1975 issue of *Rod and Custom* magazine and was one of the very first hot rods at the St. Ignace Car Show.

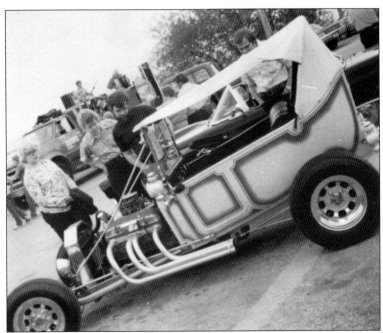

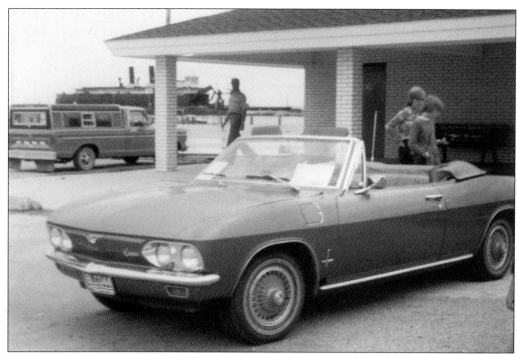

Early exhibitor Sam Chipman brought his teal 1967 Chevrolet Corvair convertible. The Corvair's nice looks were overshadowed by the controversy about its engine placement in the rear. Was it really safe? The ice-breaking railroad ferry *Chief Wawatam* appears in the background.

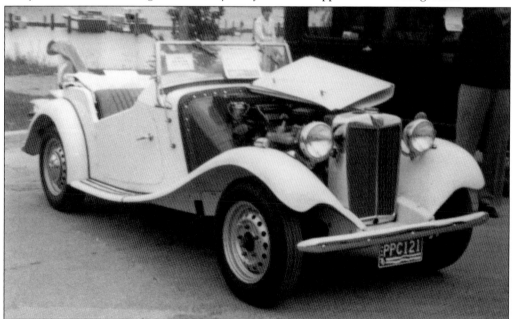

A change of pace in an early show was this eye-catching 1951 MG-TD. Ed Russell, of Sault Ste. Marie, Michigan, owned the ivory convertible. The car had a red-leather interior, a red grill center, and red firewall. It was also equipped with a fold-down windscreen, manual top-down operation, "suicide" doors, and a bi-fold bonnet.

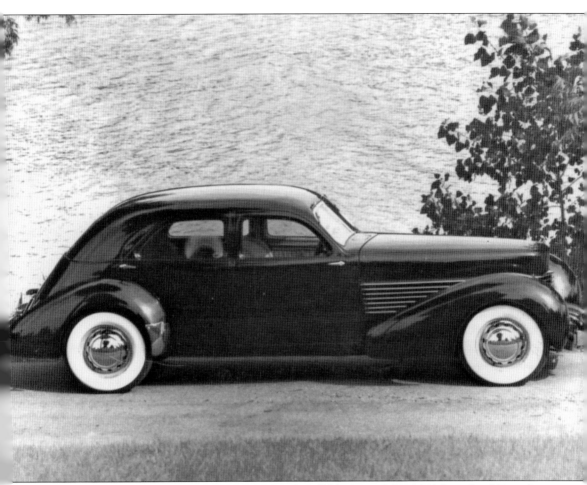

Referred to as "the most beautiful car ever built," this all-black 1936 Cord 810 (armchair) Beverly Sedan was shown as a feature car at the first St. Ignace Car Show. This splendid automobile was purchased new by a "lady of the oldest profession," who kept it for 13 years before trading it in on a 1949 Pontiac. Don and Sally Randall still own it after 51 years. The lovely Cord is the only car ever completely designed by one man, Gordon Buehrig. It offered many innovative features: chrome inner horn ring, rheostat instrument panel lighting to adjust brightness, a radio antenna placed horizontally beneath the auto to preserve the sleek body lines, and an interior offering comfortable overstuffed armchair-type seating, front and back. This exquisite automobile was studied, measured, and photographed by Oldsmobile to design their "all-new" Toronado, which incorporated many Cord features, including front-wheel drive, disappearing headlights, and slotted hubcaps. The Randall's Cord was also present at the Toronado debut held on the grounds of Gordon Buehrig's home. (Don and Sally Randall.)

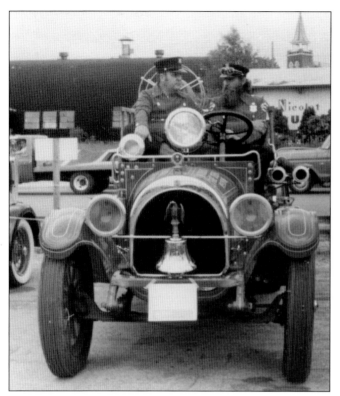

Not every first-year entry was a car. A 1918 Oldsmobile fire truck arrived from the Hamburg, Michigan, area. Firefighters in period garb accompanied the bright red, heavily pinstriped vehicle.

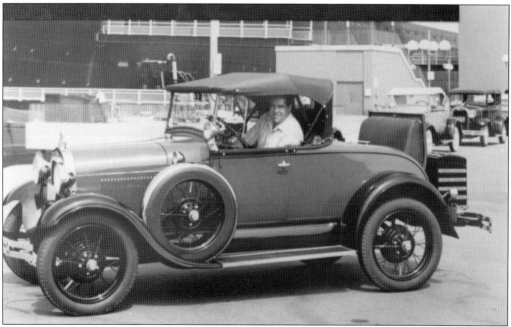

Bob Ray's 1929 Model A Roadster had what was considered a perfect paint job. The car sat in a garage for four years to let the Rose Beige and Seal Brown paint cure. Bob (driving) bought the "A" in Houston in 1960 for $200, including a trailer. Restoration began in 1968. It was dismantled and all parts, including nuts and bolts, were cleaned, painted, re-chromed, or replaced.

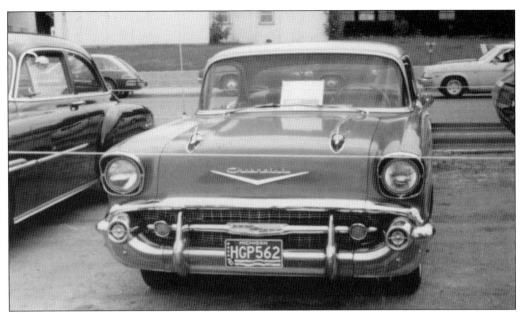

Entrants in the 1976 car show included the very popular 1957 Chevy (above) and the classic Corvette (below). Through the years, more of State Street was closed off and entry units grew into the thousands. Extras were added, including an antique boat show, cruising, parades, the Mackinac Bridge Rally, Muscle Car Madness, deejays and live bands, receptions, feature cars, guests of honor, swap meets, car product vendors, food, brunches, concerts, car and engine raffles, hostesses, movie stars, organized road tours, and even a full wedding one year. Other related events were spawned, such as Antiques on the Bay Car Show, Richard Crane Memorial Truck Show, Owosso Tractor Parts Antique Tractor Show, a pedal car show, and a model car contest.

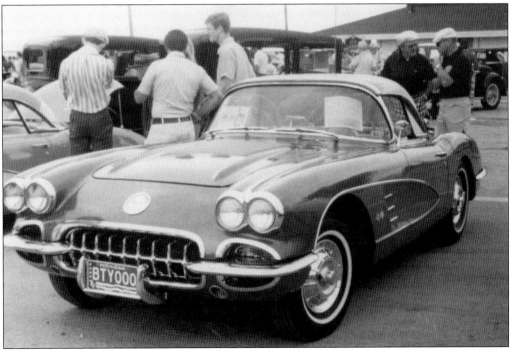

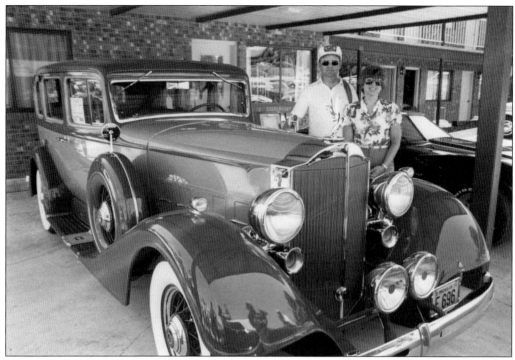

Bruce Dodson's 1934 Packard (1977 Best in Show winner) was original except for light and dark Gunmetal Pearlite paint. It had many unique features: thermostatically controlled radiator shutters, ride control operated by the driver, power brakes with a dash switch for more or less power, and a chassis lubricator that worked when the automobile was in motion. Bruce is shown here with his wife, Carolyn. (Bruce and Carolyn Dodson.)

At the first annual car show, the oldest vehicle entered was Ron Blanding's 1909 Packard Model 30, which was voted Best in Show by the spectators. Purchased in 1975, Ron's gleaming brass, five-passenger touring car featured carbide lights and a crank starter. The all-black horseless carriage with cream wheels was one of the *Somewhere in Time* automobiles. (Ron Blanding.)

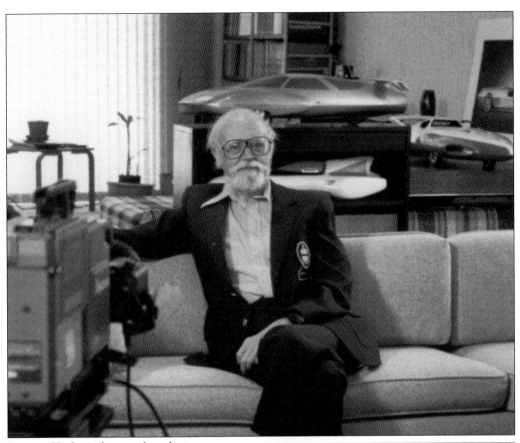

Preston Tucker's dream of producing a "completely new" passenger vehicle resulted in 51 innovative Tucker automobiles. These cars offered a third swiveling center headlight, fastback styling, independent four-wheel suspension, and rear-mounted Franklin modified helicopter engines. The safety features included padded sun visors, a recessed padded push-button dashboard, pop-out windshield, collapsible steering column, three roll bars, seat belts, and disc brakes. In 1989, a dark-green 1948 Tucker sedan came to visit at the St. Ignace Car Show, loaned from the Auburn-Cord-Duesenberg Museum in Auburn, Indiana. Designer Alex Tremulis (above) joined Tucker family members, Mary Lee Tucker McAndrew (right), and Melissa Tucker Bailey, who came to celebrate the vision of Preston Tucker's revolutionary automobile. (Above, Alex Tremulis.)

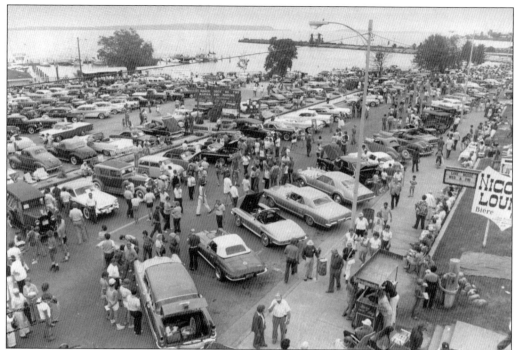

Although the show spreads for almost two miles along State Street, this photograph shows the marina area. The marina was formerly the site of Michigan State Car Ferry Dock Two. Before the Mackinac Bridge opened in 1957, lineups of cars were not uncommon here as folks waited for the next ferry to take them south over the Straits of Mackinac.

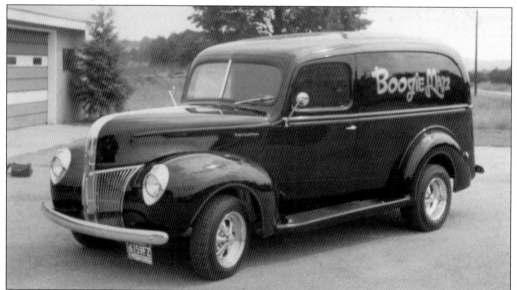

This 1941 Ford panel delivery truck had previously won more than 30 trophies. On display in an early show by Denny and Suz Reamer, the black-lacquered *Boogie Man* featured a full bar, television, jukebox, and beamed ceiling. The power plant was a Rochester-injected 350 Chevrolet Turbo 400. This beauty has been featured in *Car Craft*, *Hot Rod*, *Street Scene*, and *1001 Custom and Rod Ideas*. (Denny and Suz Reamer.)

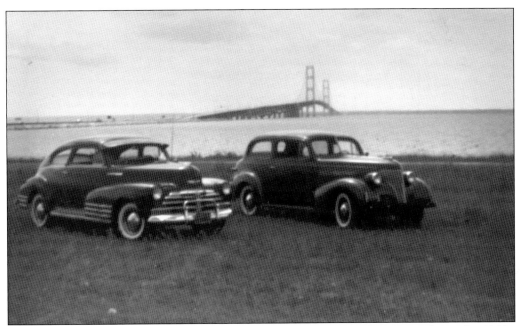

Despite the belt tightening of World War II, automotive styling took giant strides in the 1940s. Bob Blair's 1939 Chevrolet Town Sedan (right) and Ed's 1948 Chevrolet Fleetline are worlds apart in styling. Perfectly posed with the magnificent Mackinac Bridge as a backdrop, this humble snapshot takes on a professional air—ah, those Chevy calendar girls.

Bittersweet body paint, brown fender, and stripe under the windows with red steel spoke wheels make this Buick so very colorful. Chrome bumpers, running-board trim, hubs, and light housings, in addition to the white spare tire covering, add a sparkle. The road ahead was well lit by a myriad of lights. This glorious automobile was entered in an early show.

Working in Michigan since the 1950s, Paul Hatton is a legend in the custom-paint world. Based at Hatton's House of Crazy Paint in Garden City, Michigan, he is a wizard with a striping brush. Hatton is shown here putting pinstripes on Nostalgia's raffle car, a 1934 red Ford coupe, at Autorama in Detroit.

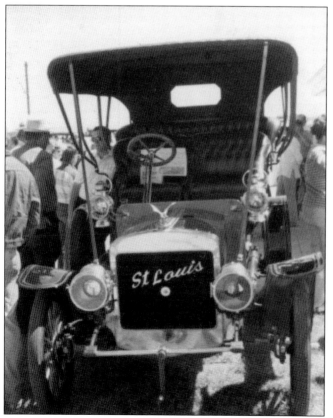

The story goes that the very first horseless carriage drove into St. Ignace in 1908. No record exists with details about that first car, but it could have been one like this 1904 St. Louis. Paul Jonas brought this four-cylinder, black brass car with red seats and chassis to an early car show. This exquisite auto is believed to be the only remaining St. Louis in the world.

What could be better than viewing splendid vehicles on a beautiful summer day? A person can chat with the owners, taking plenty of time to look at the eye-catching beauties and daydreaming about a favorite, and reminisce about a first (and second and third) car. (Sam Hosler.)

Some of history's finest customs came from the "A-Brothers," who initially offered general repairs, restoration, and a few custom tricks. In 1957, Mike (right) and Larry Alexander opened their Detroit shop on a shoestring budget with only $300. They had a sense of detail and a great ability with tools. George Barris dropped in and took some photographs, which were published in *Hot Rod* and *Rod and Custom* magazines.

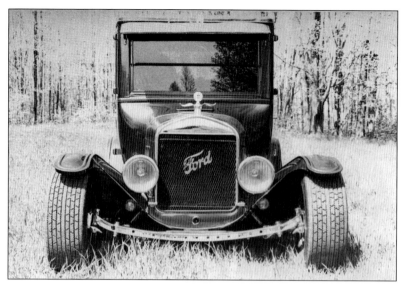

An eye-catching 1923 Tall T arrived from Thessalon, Ontario, Canada, for the first St. Ignace Car Show. The striking candy-apple burgundy Ford owned by Dave and Nancy Seabrook took the Best in Show Modified award in that initial show. (Dave and Nancy Seabrook.)

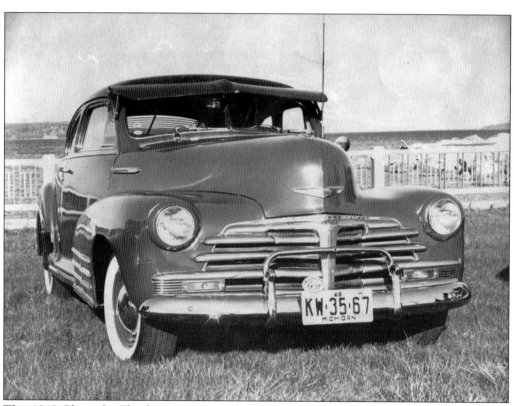

This 1948 Chevrolet Fleetline Aero two-door sedan sported rear Venetian blinds and wiper, a Fulton sunshield, wide whitewalls, and blue dot taillights. Priced at $1,434 from the dealer, this dark-blue beauty was valued at $3,500 by 1976. The top-of-the-line model was restored by owner Ed Reavie using new old stock parts. The Fleetline sparkled with new paint and re-chromed brightwork.

Bucky McPhee's 1949 Packard came from Georgia and had been restored to all original before he bought it in 1976. The elegant navy-blue paint job was achieved with 17 coats of hand-rubbed lacquer. This winning luxury automobile was hard to beat in show competition. In the seven years he kept it, Bucky's four-door sedan took many awards around the state.

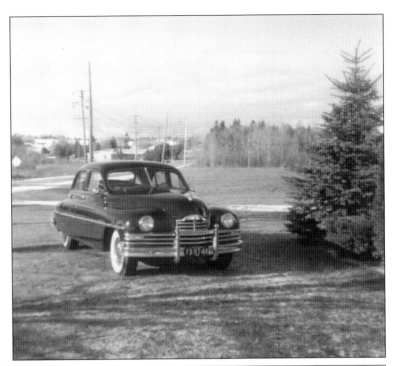

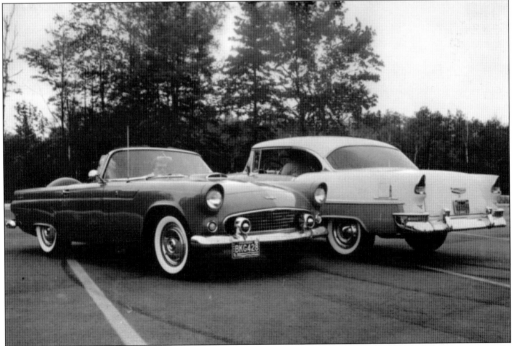

Even to non-car folks, these are two of the most recognizable automobiles from the 1950s: a 1956 Thunderbird (left) and a 1955 Chevrolet. Don Angelo, WIDG radio station general manager, owned the T-Bird, and the Chevy still lives in Ed's garage. Don's car sports Michigan's red, white, and blue 1976 bicentennial plate, while Ed retains the California plate that came on his car in 1976.

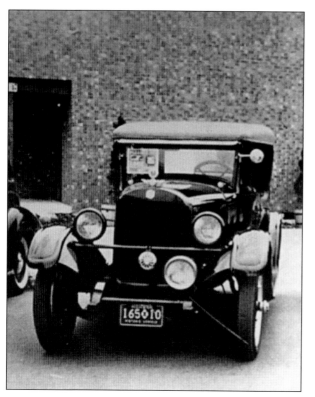

Gary Olsen's 1925 Studebaker Duplex Phaeton was one of the first two cars to cross the Mackinac Bridge, driven by then-owner Emil Syverson. The Studebaker featured side window curtains, an engine temperature gauge on its hood, wooden spoke wheels, two-wheel brakes, and the dependable L-head, six-cylinder engine. The original owner's manual describes not only the car's features, but instructs the new owner on how to drive.

Dan Webb is an internationally known specialty vehicle builder. He won a Ridler Award seven years ago and was recently featured on the cover of the prestigious *Rodders Journal*. He and Thom Taylor collaborated on the *Golden Submarine*, which took Best in Show at the 2008 SEMA (Specialty Equipment Marketing Association) trade show. For a decade, he designed and manufactured unique awards that were works of art for the St. Ignace Car Show. (Joe Joliet.)

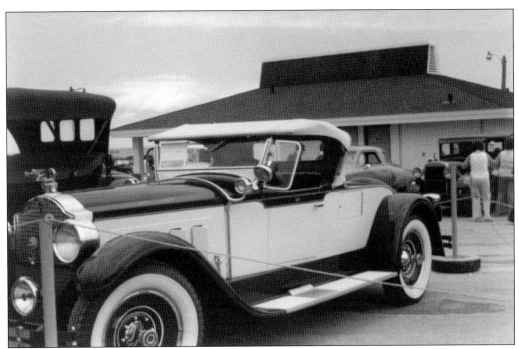

Lloyd Shute shared his sporty 1928 Packard Roadster with the 1976 car show spectators. The roadster has a small door in front of the rear fender, which opens into a compartment specially sized to carry a golf bag to the country club.

Patricia Chappell, shown with her husband, Richard, wrote *The Hot One: Chevrolet, 1955–1957* and the *Standard Catalog of Chevrolet, 1912–1990*. She is a contributing author for the *Chevrolet Chronicle* as well. Pat can advise on the smallest detail of what to look for when buying a stock mid-1950s Chevy as authentic for showing.

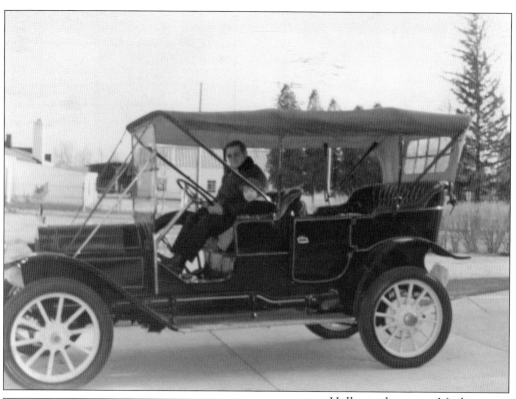

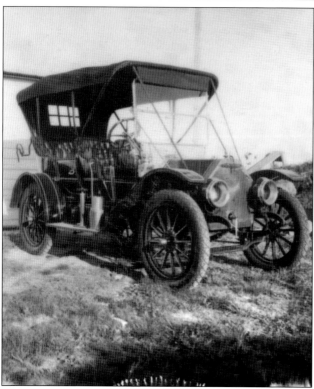

Hollywood came to Mackinac Island to film *Somewhere In Time*. Ed received a request to help line up a few pre-1912 horseless carriages to be in the movie. Several pioneer automobiles were offered: a 1911 black Cadillac with ivory wheels (above), owned by Francis Burns, and a 1910 burgundy Oakland with a black roof and interior (left), owned by Bud Jonas. Also offered were Ron Blanding's black 1909 Packard, Bud Jonas's 1913 Rambler, and Paul Jonas's 1904 St. Louis. The big day came, and Ed was on the Favorite Dock waiting. Down the hill from the south came the five brass cars ticking resolutely along for their appointment with fame. Across Moran Bay, the flattop freight ferry thrummed in to load and transport the fragile-looking machines to the island. (Above, Francis Burns; left, Bud Jonas.)

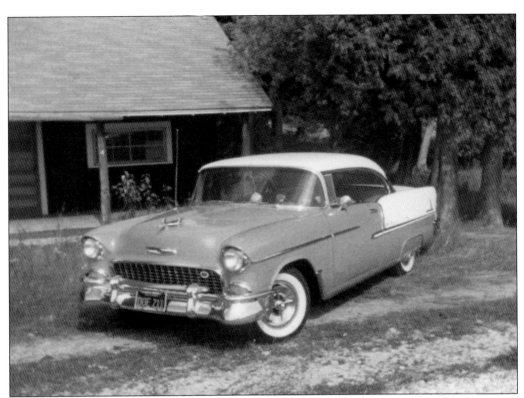

Ed bought this regal turquoise and India ivory 1955 Chevrolet Bel Air, with a 265 V-8, Powerglide, and full power, in 1976. Shown at right with broker Bob Wingate (left), Ed is the third owner of the superb California automobile. The Chevy was on the show circuit for 15 years before it was retired after winning the Antique Automobile Club of America's Junior, Senior, and Preservation Awards. It was also featured on 10 magazine covers. Still owned by Ed, it sports spinners, skirts, and dual glasspacks. It was born and raised in California and is now a nice day cruiser in St. Ignace.

Craig Shantz is the manager of GM Performance Division and Chevrolet Creative Services, builders of the specialty show vehicles and pace cars. These divisions lead the way for performance-based production cars and trucks. Under his leadership, the St. Ignace Car Show has received several crate engines for local fund-raising and specialty awards for winning show vehicles. GM's spectacular displays have been the centerpiece of the show for many years. (Joe Joliet.)

"Say kids! What time is it?" Buffalo Bob Smith would ask of the Peanut Gallery. This question started *The Howdy Doody Show* for 13 years (1947–1960). Buffalo Bob tried to keep order in Doodyville, USA, as a cast of zany characters and marionettes entertained a huge television audience of kids. In 1995, Ed hosted Buffalo Bob and Howdy Doody, one of three identical marionettes used on the show.

Artist Dave Bell made St. Ignace known to the automotive world through monthly artwork such as "Henry Hirise" in *Street Rodder* magazine and "Nate Moddle" in *Custom Rodder*. His artwork is also seen on T-shirts. He was inducted into the Hall of Fame North in 1990. (Dave Bell.)

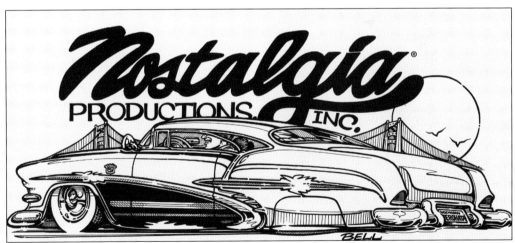

By 1987, Nostalgia Productions, the parent organization of all Ed's events, was incorporated, and Ed decided a trademark was needed in 1996. Hired to create this logo, automotive artist Dave Bell chose a custom, combining two of Ed's favorite cars. Can the reader spot the 1955 Chevy and the Barris custom *Hirohata* 1951 Mercury? To show a regional flavor, Dave integrated seagulls and the Mackinac Bridge—perfect!

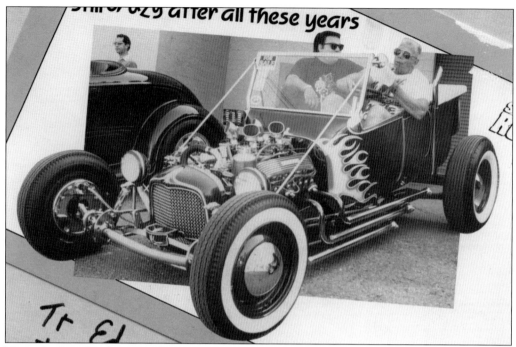

Norm Grabowski's first T-Bucket hot rod became the Kookie 77 Sunset Strip car. That car was a combination of "A" and "T" bodies and was powered by a Cadillac engine. Later he also became a Hollywood stunt driver and bit player. Grabowski, a one-of-a-kind character, was once pulled over in St. Ignace for riding his motorized bar stool. In 1991, he was inducted into the Hall of Fame North. (Norm Grabowski.)

Known as the "Ambassador of Auto Sports," Leroi "Tex" Smith has written about every aspect of automotive sports and many how-to books. The 1990 Hall of Fame North inductee builds one-of-a-kind hot rods, including the 1963 America's Most Beautiful Roadster. That metalflake candy-apple tangerine 1927 Model T body on a tube chassis had a Volkswagen front end and rear suspension from a Dodge Dart and was called *XR-6*. (Leroi Smith.)

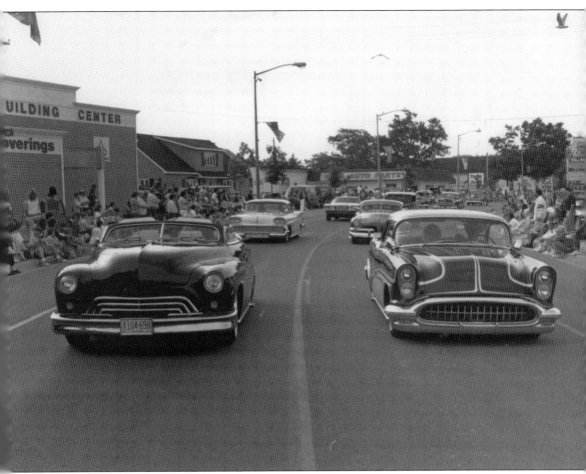

For 28 years, Merv Wyse has directed the spectator-pleasing Down Memory Lane Parade, kicking off car show weekend in style. The cars are at their finest, doing what they were always meant to do. People are witness to the rattle of glasspacks, the distinctive cadence of a horseless carriage, the big snarl of a muscle car, the sedate purr of a family automobile, and the mystery of a plain Jane until she explodes into her banshee wail. A rainbow of color flashes by: metalflakes, candy apples, flames, custom paint jobs, two-colors, tricolors, chrome, brass, glass tints, pinstripes, and things people have never seen before. They are waxed, polished, buffed, and chamoised—even the tires are clean. They include roadsters, customs, rods, stocks, racers, rat rods, kit cars, and pickups as well as cars that are lowered, chopped, lifted, raked, de-chromed, or equipped with hydraulics, blowers, side pipes, sissy bars, and even parachutes. There are convertibles, sedans, coupes, hardtops, and some look just like they came from the factory. They are all wonderful, and it is easy to be almost overwhelmed. (Joe Joliet.)

When he was nine, James Dean's mother died and his father sent him to live with his aunt and uncle in Indiana. He lived there until he graduated from high school. In 2005, James's cousin, Marcus Winslow Jr., came to visit on the 50th anniversary of the star's untimely death. His short career in Hollywood produced three films: *Rebel Without a Cause*, *Giant*, and *East of Eden*. (Joe Joliet.)

Ron Clark and Bob Kaiser (right, with Ed) were collectively Clarkaiser Customs, Michigan's first custom shop. Clarkaiser started creating one-of-a-kind vehicles in the 1940s in Detroit. Superior skills in lead and steel made Clarkaiser a standout in the customizing world. Their cars were entered in 68 shows and amazingly enough took home 68 first-place awards. Bob was a 1989 inductee into the Hall of Fame North.

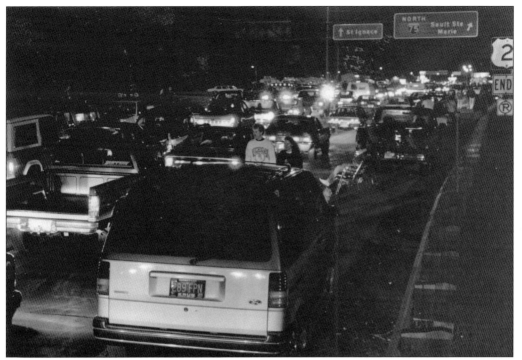

During the decade when cruise night had the Big Boy restaurant as its destination, there were five lanes of gridlock, plus all the spectators gathered on the sidelines along U.S. 2. St. Ignace, a city of about 2,600, bulged at its seams.

During his tenure at General Motors, Jon Moss (left, with Ed) was in charge of specialty vehicles. He brought many GM performance displays to St. Ignace over the years. In 1998, he was a featured guest at On the Waterfront Car Show. This is a smaller show held in conjunction with the truck show each September. Now retired, he is still connected to the automobile industry.

Jerry Patlow provided all the rock 'n' roll shows during the years of St. Ignace Car Show's live concerts. He also organized major cruises from the Detroit area to St. Ignace. He was the entertainment go-to guy for Nostalgia Production events. (Joe Joliet.)

Jennifer Brown, from Howard City, Michigan, was Miss Nostalgia Productions. Beginning her tenure in 1993, she reigned for several years. Jennifer was very popular, signing thousands of posters and pictures. Traveling with the raffle vehicle to many shows, she always had a lineup of fans.

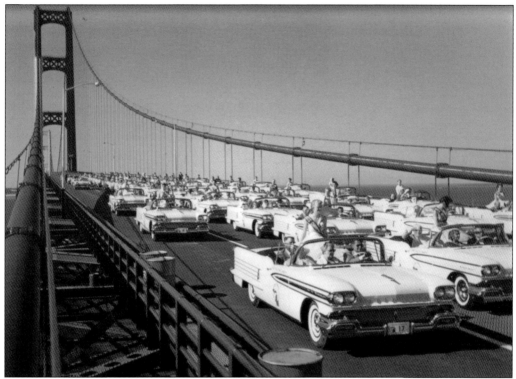

Though the official opening of the Mackinac Bridge was November 1, 1957, the formal dedication was in June 1958. GM's Oldsmobile Division provided automobiles for the parade, mostly 98s and Super 88s. Among them were 83 white convertibles with white interiors, one for each of Michigan's 83 counties, transporting a dignitary and a county queen or princess in each one. (Mackinac Bridge Authority.)

This Harvest Gold and India Ivory, with Neptune Green interior, one-owner 1955 Chevrolet was "a find" for Ed. Coming from the estate of a 90-year-old woman, the car was all original. With only 16,000 miles, it still smelled new—in 1978. The four-door, 265 V-8 two barrel had been driven only on nice summer days. All of the car's original paperwork came with it.

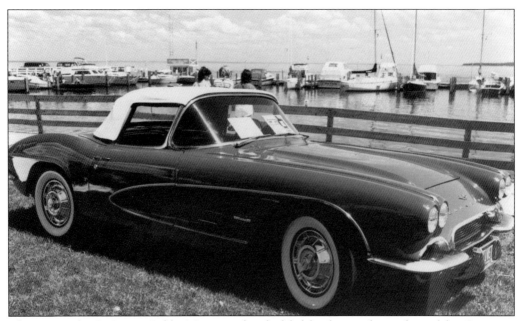

The spectacular St. Ignace Public Marina is the ideal foil for the timeless styling of this Corvette. The picturesque shoreline of the big lake and the picture-perfect vehicles combine to form the essence of what makes the St. Ignace Car Show unique and preeminent.

"If you knew Peggy Sue," sang Buddy Holly and the Crickets in 1957. There was a real Peggy Sue—Peggy Sue Gerron (shown with Sean Reavie) was the girlfriend of the Crickets' drummer. Previously she has been a small-business owner, writer, and even the first licensed female plumber in California. Today she is a columnist, radio host, and celebrity speaker, and she visited the St. Ignace Car Show in 1998.

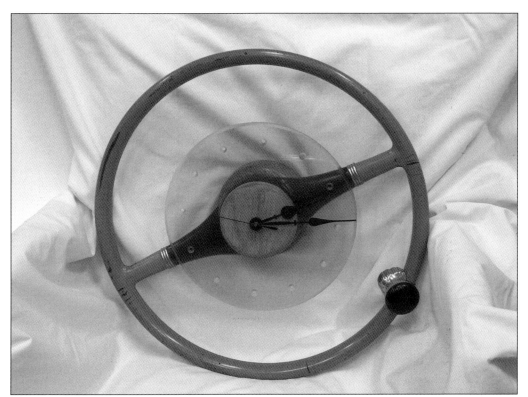

This clock is made from an elderly steering wheel with a Brodie knob. The knob (known by different names across the country: suicide, granny, or necker knobs) made turning easier in cars without power steering. Under acceleration, turns could be quite sharp, and doing half a doughnut became "laying a brodie." These inexpensive knobs came in many colors and designs, including chrome and eight ball. (Eileen Evers.)

Curt Fischbach was educated as an automotive engineer, gravitating toward convertibles. He has made a career in the development and production of convertible tops and retractable hardtops. Since 1993, he has worked with Nostalgia Productions to arrange sponsorships of its events. In addition to lending two of his own, he helped to arrange 5 of the 52 convertibles for the Mackinac Bridge 50th Anniversary Parade in 2007.

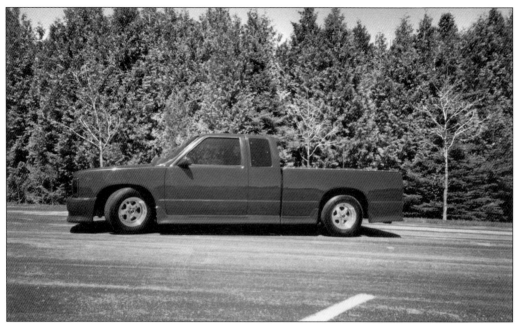

The Nostalgia truck, a 1991 S-10, was kept stock for one year. After a trip to Lee Ortman's Motion Auto, it became an eye-catching trick truck in solid burgundy with tinted windows and custom wheels. Lowered by Bell Tech front spindles and Posie Super Slide rear springs, it has no airbags. The V-6, five speed is stock. It has Ford Tempo taillights and blue dot lights above the rear window.

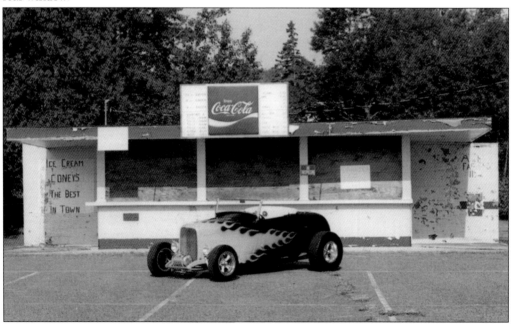

With phantom echoes of rock 'n' roll, Bootsie's Drive-In—a past haunt of carhops on roller skates—was once the cruise night destination. The dazzling black Ford with requisite flames belongs to Chris and Dawn Hockaday. This hot rod looks and sounds just right. (Chris and Dawn Hockaday.)

Three
CALIFORNIA DREAMIN'

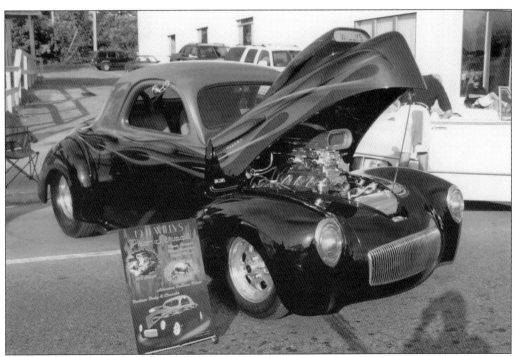

A superb 1941 Willys Pro Street Rod exhibits a flawless paint job. The black lower body is complemented by non-typical, body-length flaming in red, orange, and a touch of gold. This lowered, super-charged jewel looks quick, even while sitting still. (Joe Joliet.)

The pinstriped red 1949 Merc (above), the two-tone green 1951 *Hirohata* Mercury clone (below, in front), and the two-tone blue *Blue Danube* (below, behind) are all glorious examples of the customizing art. Automotive customizing had its beginnings in the late 1940s in California. These radically changed cars were thought provoking and eye-catching. Innovative customizers and their fantasy art knew no limits—everything was new and untried. These automobile artists attracted the attention of the St. Ignace teens. In Michigan, the reality was harsh winters of snow, sleet, ice, and salt, but their daydreams were of California's sunny days and customs, hot rods, and old radically retooled automobiles. Ed always wished to travel to his own personal mecca—California. Finally in the winter of 1991, he flew into Sacramento. Joe Bailon collected him, and the California odyssey began. (Both, Joe Joliet.)

On Ed's first trip to California, Joe Bailon took him around to meet the auto pros. Joe had been a customizer from his teens and had his own shop. Innovative tubular front bumpers, custom grills, chrome reverse wheels, plow disc hubcaps, air scoops, rich candy-apple paints, and the use of electrical conduit pipe in fabrication were developed in the Bailon shop.

As a teenager, Rod Powell attended his first roadster show in 1958. He saw the creations of Barris, Watson, and Jeffries and other colorful show cars. Flames, scallops, and pinstripes were everywhere he looked, and he decided that he wanted to do this work, too. He has had his own shops, done work for other builders, and is responsible for several noteworthy customs of that era. Rod was inducted into the Hall of Fame North in 1992. (Rod Powell.)

Dean Jeffries (left, with Ed) began his career working in the Barris shop. Early on, Dean transitioned over to building and driving movie stunt cars. The *Monkeemobile* 1966 GTO and Green Hornet's *Black Beauty* (actually a pair of 1966 Chrysler Imperial customs) were his creations. Dean Jeffries designed variations for some MPC models, and seven million of the Monkeemobile model car kits were sold.

John LaBelle moved to California as a teenager. He always liked things with wheels. By age 12, he owned a Harley and his first car, a 1929 Pontiac. He worked on that car every day, though he was too young to drive it. His main interest now is 1950s hot rods and customs, especially magazine cars, with all their accompanying memorabilia, and he owns a reproduction Kookie's 77 Sunset Strip car.

Frank DeRosa builds customs that are sculpted into incredible rolling fantasies. He has won many awards for innovative design and technical excellence. He and his son Frank Jr. run a busy custom and restoration shop that is always ahead of the curve. Frank helped to bring customs back to popularity in the 1970s. He was inducted into the Hall of Fame North in 1993.

Joe Wilhelm built roadsters and customs and was a man of infinite patience. He is shown here with his *Mark I Mist*, a sectioned 1936 Ford. Probably his most well-known creation is *Wild Dream*, 1968 winner of America's Most Beautiful Roadster Award. That 1923 Ford roadster had a black interior, chrome frame, an all-chrome Chevy engine, and gold metalflake paint edged in tangerine. (Joe Wilhelm.)

Perhaps the most famous 1934 Ford three-window coupe in the world, *The California Kid*, was created by Pete Chapouris. Finished in traditional black with flaming by Manuel Reyes, the car appeared on the cover of the November 1973 *Rod and Custom* magazine. Powered by a 1968 Ford 302 V-8, the car starred in the movie *The California Kid* with Martin Sheen. Pete has worked in many facets of the auto world, even customizing a pair of Harley *HogZZillas* for Billy Gibbons of ZZ Top. Pete was inducted into the Hall of fame North in 1991 and is now president of So-Cal Speed Shop. (Left, Pete Chapouris; below, Joe Joliet.)

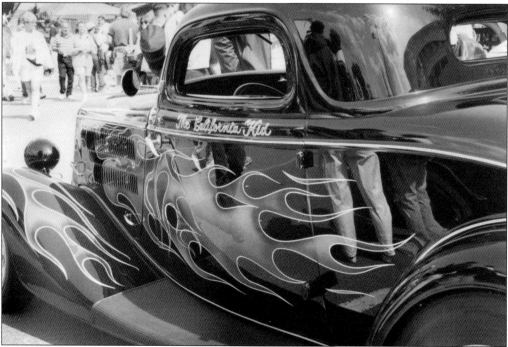

Frank and Kathy Livingston were the perfect hosts because they knew everyone in the business from Sacramento to Los Angeles. Ed first heard of Frank when his cool California cars started to get magazine coverage and he was president of the famed Satan's Angels car club. Thanks to Frank, Ed's "California Dreamin' " mind-set was complete. Frank was inducted into the Hall of Fame North in 1995.

In his high school years, Bill Cushenbery worked in his uncle's shop after class. He could take anything apart, customize it, and reassemble it. He had his own shops, first in Kansas and then in California. For a while he also did freelance work for George Barris. Several Cushenbery customs have been found and restored to their original beauty. Bill was inducted into the Hall of Fame North in 1991.

Art Himsl (left, with Bill Reasoner) and brother Mickey built outstanding cars at their Custom Paint Studio. Art's creative genius and innovative paintwork gained him a one-man show at the San Francisco Art Institute called "Hot Rod Esthetic." One of Art's paint jobs won an America's Most Beautiful Roadster Award for a 1923 Ford roadster pickup sporting a white pearl base with a psychedelic design and gold leaf lettering. Art was inducted into the Hall of Fame North in 1992.

Pat Ganahl still owns, shows, and races his first car, a 1948 Chevy, and many other owner-built cars. He has been a teacher, editor, and contributing journalist to many of the most popular automotive magazines and now does freelance photography and writing. He has written books and authored monthly columns. Pat (with Linda Vaughn) is the only journalist inducted into Kustom Kemps Hall of Fame. He became part of the Hall of Fame North in 1990. (Joe Joliet.)

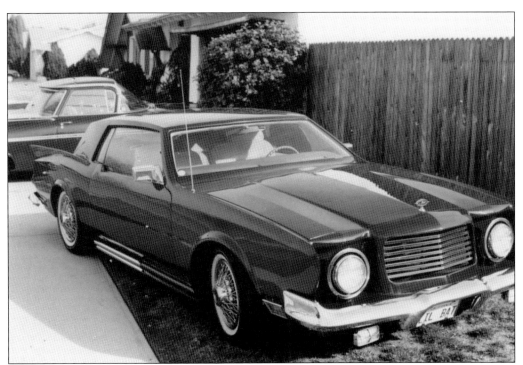

Starting to work on cars at 19, Bill Hines says he will be working on customs like this one until he is 88. He is known for being the first to use hydraulics on low-riders, sunken antennas, side pipes, folding padded Carson convertible tops, and for his fantastic fins in 1955. Known as the "Lead Slinger," he was Grand National Roadster Show's Builder of the Year in 1998 and was inducted into the Hall of Fame North in 1996.

Harold "Baggy" Bagdasarian is a pioneer of the custom and hot rod show circuit. As president of an early car club, The Thunderbolts, he managed their first show in 1951. That show became Autorama; later, he owned its rights. Acquiring the Grand National Roadster Show in 1974, he ran it up until his 1990 retirement. A 1992 Hall of Fame North inductee, Baggy has done it all in the car show world. (Harold Bagdasarian.)

California rodder Gary Meadors wanted car shows to be open to all street machines, rods, and muscle cars. He formed Goodguys Rod and Custom Association, which has become the largest automotive organization with 70,000 members. Yearly Goodguys stages 24 shows in U.S. cities, attracting up to 3,500 display vehicles at each. These first-class events encompass all types of cars and trucks, usually in an outdoor venue. (Gary Meadors.)

Gray Baskerville got paid to do what he loved—photographing and writing about cars, cars, cars, but specifically hot rods. His first car was a primered V-8 coupe to cruise the streets of his hometown, Pasadena. An enthusiastic dyed-in-the-wool car guy, he was a senior editor at *Hot Rod* magazine for over 25 years. (Gray Baskerville.)

"Tommy the Greek" Hrones (left) started work in his uncle's auto paint shop in 1925. Though now best known as a quick high-caliber pinstriper, in those early years he put in his apprenticeship in mechanical work, including polishing, waxing, and paint prep work. During the Depression, he striped cars for 75¢ to $3 each. He has pinstriped fire trucks, airplanes, race cars, boats, dragsters, helmets, and even toilet seats.

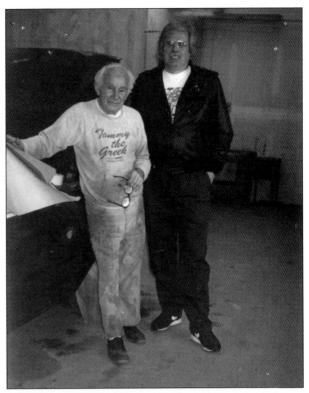

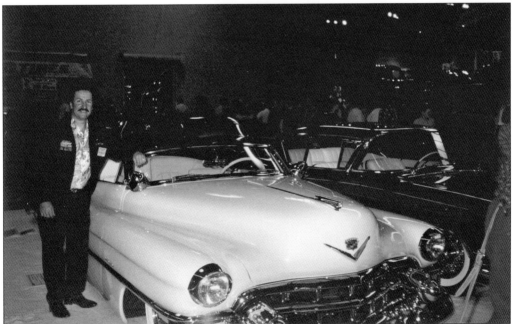

Customizer John D'Agostino stands with one of his dazzlers, a 1953 Cadillac Eldorado that was formerly a Coupe de Ville. D'Agostino created cars themed around Elvis Presley, Marilyn Monroe, and Clark Gable. John and his works of art have traveled overseas for shows. For the last decade, his customized creations have gone over into the extra-extraordinary. (John D'Agostino.)

Gene Winfield started building hot rods in 1944 and has built cars for films and television. The *Get Smart* car, created by AMT Corporation and built by Gene, was based on a 1966 Sunbeam Alpine. He still designs and builds breathtaking cars that continue to win awards. Some of the most spectacular paint jobs come from Gene's shop.

Noted collector Bruce Meyer (with Linda Vaughn) is a car guy who is interested in historic hot rods. He revitalizes them and keeps them in his huge museum-like garage or loans them to the Petersen Museum in Los Angeles. Clark Gable's Mercedes 300 SL with gull-wing doors is in his collection. He also has cars that were formerly owned by Carol Lombard and Steve McQueen. Bruce was welcomed into the Hall of Fame North in 2001.

Watching his brother Ben help Joe Bailon chop a 1941 Chevy coupe started Bill Reasoner's love of customs, and he eventually had his own shop. The 1960s muscle car mania caused the popularity of customs to fade. Bill was one who never lost his love of the sleek customs. He is known for his flawless bodywork and out-of-this-world paint jobs, winning him many awards, including induction into the Hall of Fame North in 1992.

As a boy, Rick Perry dreamed of entering a car in the Oakland Roadster Show and wore out the pages of his *Hot Rod* magazines. Rick drag raced early on and moved into super modified racing later. Rick was officially accepted into the Hall of Fame North in 1998. He had his own shop and now owns and holds the San Francisco Rod, Custom, and Motorcycle Show in the Cow Palace, the site of the first West Coast Beatles concert.

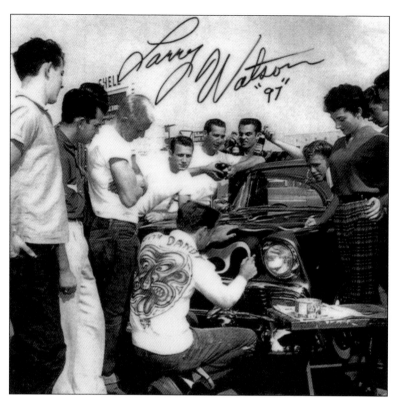

Larry Watson began his career working in his father's driveway after school. He customizes by painting, not chopping or altering. He developed lace painting and specializes in pinstriping and innovative tri-tone colors. His famous 1950 Chevrolet *Grapevine*, the first real low-rider in print, had no hydraulics or airbags. Watson (pictured flaming a 1956 Chevy) has also done extensive movie and television work with automobiles, and he is still at it.

Blackie Gejeian built his first car, a rat rod, in 1946. He was a dirt track racer and helped to pioneer the indoor car show formula. For 50 years he has run the Fresno Autorama. Unlike most shows, only invitees are allowed to participate. Shown here is Blackie's *Shish Kabob*, the black 1927 roadster that won him the 1955 America's Most Beautiful Roadster award.

Four

The VIPs

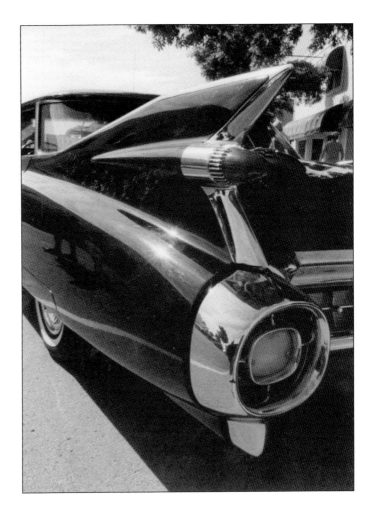

Big fins, big chrome, big cars—the opulent 1959 black Caddy was a standout, trumping the class of '59 in the art of excess. It symbolized the 1950s and anticipated the 1960s with a hopeful anything-is-possible optimism. Some people use the word overdone, but all heads turn when one of these grand automobiles floats by. (Joe Joliet.)

As Dean of automobile designers, Gordon Buehrig created the Cord 810–812, Duesenberg J, and Auburn Boattail Speedster, among others. He was also director of the Franklin Mint Precision Models. The 1980 St. Ignace Car Show guest of honor suggested the Mackinac Bridge Rally, which has opened the car show since 1984. He is shown here in a re-creation of his design studio at the Auburn-Cord-Duesenberg Museum. (Gordon Buehrig.)

Vice president of design for American Motors from 1964 to 1985, Richard Teague was one of the country's leading stylists as well as a collector and toy car expert. Richard created many Packards and one-of-a-kind show cars and came to St. Ignace as the car show's guest of honor in 1981. (Richard Teague.)

The Corvette, just another car in its first two years, took on its unofficial title as "America's Sportscar" under the wing of Zora Arkus-Duntov. The brilliant engineer was a highly sought-after guest at major Corvette functions. He was St. Ignace Car Show's guest of honor in 1982.

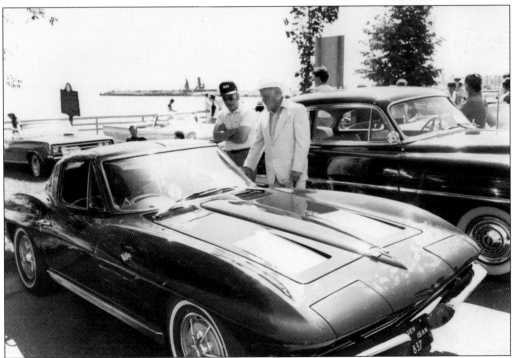

William Mitchell (at driver's door) became vice president of design for General Motors when the legendary Harley Earl retired. In 19 years, he was responsible for the look of 100 million vehicles. The Buick Riviera, Corvette Stingray, and Oldsmobile Toronado were produced under his reign. In 1983, he was St. Ignace Car Show's guest of honor.

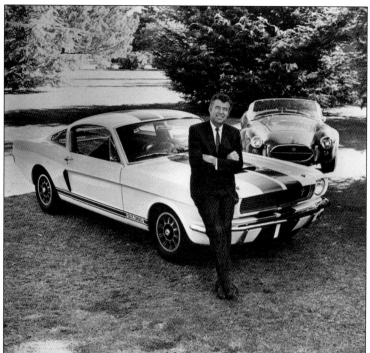

The 1984 guest of honor, Carroll Shelby, is an internationally known race driver, designer, and engineer. He is known for the Shelby Mustang, Shelby Charger, and the Cobra, one of the world's fastest production cars, which can go from 0 to 100 miles per hour and back to zero in 14.8 seconds (of course with the right driver). A living legend, he is still in serious demand for personal appearances even now in his mid-80s. (Carroll Shelby.)

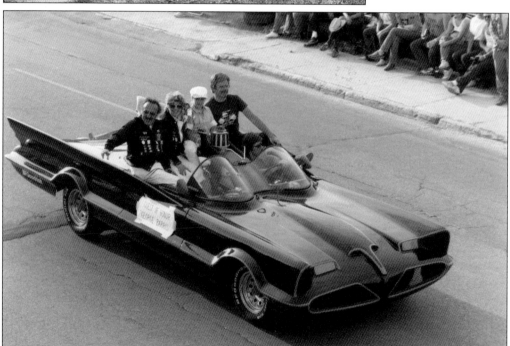

As the "King of Kustomizers," George Barris studied his craft with early customizer Harry Westergard. George promoted the famous California Kustoms, while his brother Sam built the cars. These one-of-a-kind handcrafted beauties are often seen in movies and on television. George promoted cruising and put together the first car club. Parading in the *Batmobile* are, from left to right, 1985 guest of honor George Barris, Shirley Barris, Tracy Larivee, and Ed. (Joe Joliet.)

Early on, Robert Larivee Sr. participated in legal (and sometimes illegal) drag racing activities in the Detroit area. He later became one of the world's largest car show producers, once producing 100 shows in a single year. He has been with Detroit's Autorama for over 50 years. The 1986 St. Ignace Car Show guest of honor also restores and collects automobiles. (Joe Joliet.)

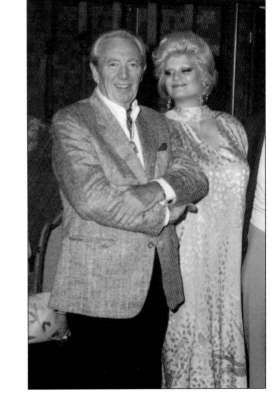

Gene Bordinat II, vice president of design for Ford Motor Company, was responsible for more than 70 million vehicles during his 20-year career. He supervised the design of the revolutionary Mark III, the Ford racing program, and the complete Mustang regime during those years. Gene, shown here with his wife, Teresa, was St. Ignace Car Show's 1987 guest of honor. (Joe Joliet.)

"Big Daddy" Don Garlits is a racing legend who revolutionized drag racing. His innovations include small bicycle-type front wheels, the first extended wheelbase, the first spoilers, the lifesaving and almost-universal rear engine dragster, the first turbine car, and fully enclosed cockpits for dragsters. He and his wife, Pat, developed the first Museum of Drag Racing in Ocala, Florida. Garlits was the 1988 St. Ignace Car Show guest of honor. (Joe Joliet.)

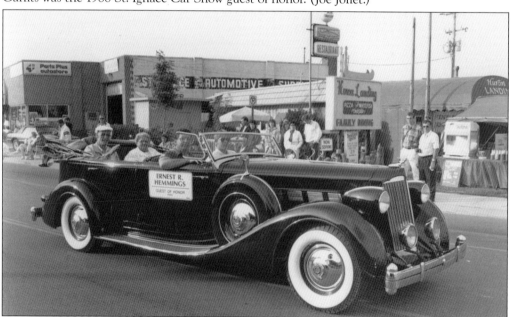

Ernest Hemmings started *Hemmings Motor News* in 1954 as a way of defraying the cost of catalogs for his father's auto parts business. Classified ads sold for 2¢ per word; the subscriptions doubled the next year. Eventually he had to hire a printing firm to replace his manual mimeograph machine. The 1990 guest of honor sold the publication and returned to the auto parts business in 1968. (Joe Joliet.)

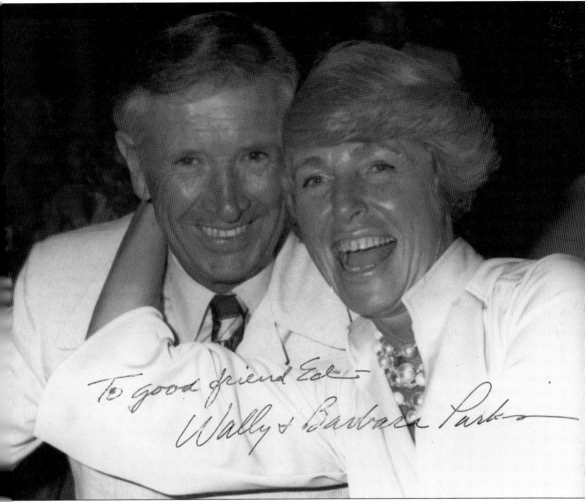

In 1951, Wally Parks founded and chaired the National Hot Rod Association (NHRA), the world's largest auto racing sanctioning body. He organized the first NHRA Nationals and developed the first hot rod car show in 1947. He assisted in developing *Hot Rod* magazine in 1948 and led the campaign to develop acceleration matches into today's major sport of drag racing. Wally was St. Ignace Car Show's 1989 guest of honor. Early on, Barbara Parks was secretary for the *Hot Rod* magazine editorial staff. Later she served as manager and headquarters contact for the NHRA's field staff. Her efforts leaned toward safety issues, and she was executive secretary of the International Car Club Association (ICCA), a 1960s spin-off of NHRA. ICCA held a series of Rod and Custom Auto Fairs and an Econability Run, a safe driver's contest between club teams. (Wally and Barbara Parks.)

Franklin Q. Hershey, the 1991 St. Ignace Car Show guest of honor, created custom bodies for Cords, Duesenbergs, Packards, Lincolns, and Cadillacs early in his 35-year career as an automotive designer. He put the trademark silver streaks on Pontiacs and set the country on its ear with the 1948 Cadillac tail fins. Among all the designs he was associated with, his personal favorite was the early Thunderbird. (Joe Joliet.)

While at Massachusetts Institute of Technology, Chuck Jordan won the GM Fisher Body Craftsmen's Guild model car competition and caught GM's attention. He is credited with the creation of the first sport truck, the Chevrolet Cameo Carrier, in 1955. The 1992 guest of honor rose to become vice president of design for GM and created many types of vehicles: trucks, buses, experimental and passenger cars, and even earth-moving equipment. (Chuck Jordan.)

America's first international racing star, Phil Hill, achieved his greatest fame in endurance racing. He won France's LeMans, Sebring, Italy's and Belgium's Grand Prixs, Argentina's 1000 Km, and the Formula One World Drivers' Championship. After more than two decades of racing without injuries, he retired in 1969. The 1993 guest of honor (right, with Linda Vaughn and Ed) was a master mechanic, collected antique musical instruments, and restored classic cars. (Joe Joliet.)

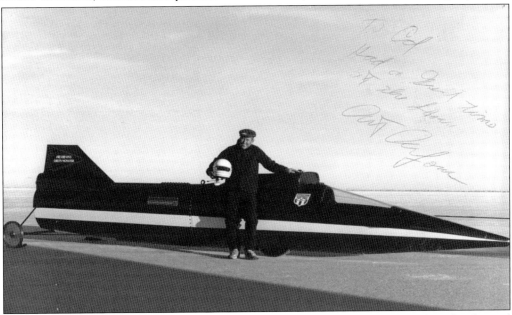

Art Arfons, whose early hobby was flying, got into auto racing in 1952 and set land speed records. His first *Green Monster* dragster was followed by jet-powered tractors. Art was honored as an inaugural inductee into the International Drag Racing Hall of Fame and later into the Motorsports Hall of Fame of America. In 1994, he was guest of honor at the St. Ignace Car Show. (Art Arfons.)

Gordon Johncock, from Hastings, Michigan, was the first Indianapolis 500 winner to preside as guest of honor at the St. Ignace Car Show in 1995. The two-time Indy champ began his driving career in 1955, racing modified cars at Flat Rock Speedway in Michigan. Now retired, he enjoys squeezing 18 miles per hour out of his tractor, polishing his 1982 pace car, and tending his cattle and pets. (Joe Joliet.)

Ed "Big Daddy" Roth was a custom painter who also designed and built bubbletop cars. He never worked with metal; all his creations were fiberglass. In later years, he was most often seen in formal attire: top hat, tails, cane, and monocle. His works of art are museum pieces and many were developed into model kits. He also originated caricature T-shirts called "Weirdo" shirts. Ed was inducted into the Hall of Fame North in 1992 and was guest of honor at the car show in 1996. (Ed Roth.)

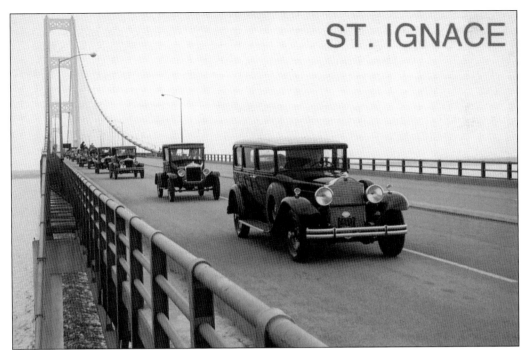

This postcard photograph shows an early Mackinac Bridge Rally coming from Mackinaw City. The smaller Antiques on the Bay Car Show takes place one week before the "big" show and was requested by exhibitors who loved these cars as they were, without changes. Many are the fragile-appearing "horseless carriages" or brass cars of the very early motoring years. Leading here is John Nieman in his 1929 black Packard. (Ron Muszynski.)

In 1997, a new car show came to town. Antiques on the Bay Car Show featured original or restored to original vehicles 25 years old or older. The guest of honor, David Lewis, is a University of Michigan professor of business history, an award-winning journalist, and public relations specialist. David is the world-renowned Ford family historian. Henry Ford's Model A was celebrated in the premiere show. (David Lewis.)

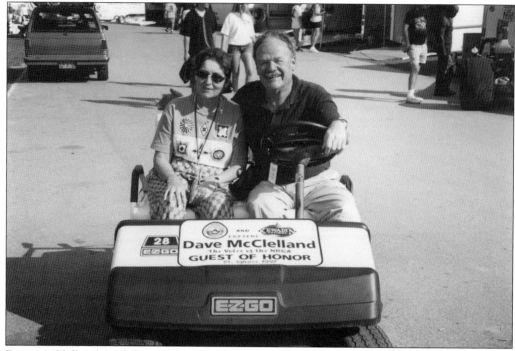

Dave McClelland (with his wife, Louise) is best known as the voice of NHRA, traveling 70,000 miles annually to broadcast their events. The 1997 St. Ignace Car Show guest of honor also narrates for television, promotes auto racing on radio and television commercials, and emcees high-class automotive events. Dave possesses a great recall of historic incidents and people, a real asset to any event.

Antiques on the Bay 1998 featured all Chevrolets, and the guest of honor was "Mr. Chevy," Murl "Pinky" Randall. As a kindergartner, he picked out his favorite car, a 1932 Chevrolet that was blue with black fenders and yellow wheels. He bought it for $30 after his military service and still owns it. He put together the world's largest collection of Chevrolet literature. (Pinky Randall.)

Six-time winner of America's Most Beautiful Roadster Award at the Grand National Roadster Show, Boyd Coddington (shown with his wife, Jo) was a creator, designer, and visionary of incredible scope. His companies were Hot Rods by Boyd and Boyds Wheels. An individualized and expertly customized appearance of smooth, seamless lines and a flare for the dramatic has been labeled "trademark Coddington." He was the guest of honor in 1998.

Bob Stevens has been a professional journalist for 43 years and is now the editor of *Cars and Parts* and six other magazines. A Corvette guy for 50 years, he collects wonderful old cars and has two motorcycles and a 1947 Chris-Craft speedboat. Bob was Antiques on the Bay's 1999 guest of honor. Brass cars were featured that year. (Bob Stevens.)

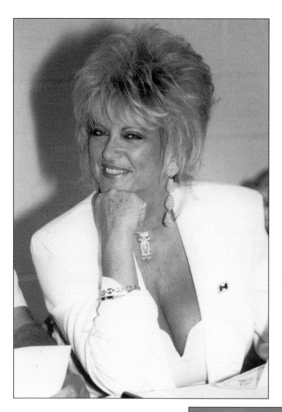

As the "First Lady of Motor Sports," Linda Vaughn gained fame in auto racing circles during 17 years of appearances as "Miss Hurst Golden Shifter" from 1966 through the early 1980s. The 1999 St. Ignace Car Show guest of honor has become a celebrity in her own right and appears at automobile events all over the United States. (Joe Joliet.)

The guest of honor at the 2000 Antiques on the Bay Car Show was John Gunnell. He spent his career at Krause Publications as writer, publisher, and editor of *Old Cars Weekly*. Gunnell has also authored over 50 books and is a Pontiac historian. The show featured orphan cars of all makes. Orphan cars are those manufactured by companies that are no longer in business. (John Gunnell.)

Keith Crain is chairman of Crain Communications. Included in the corporation's 26 publications are *AutoWeek*, *Automotive News*, and *Crain's Detroit Business*. Keith is a serious car collector, from hot rods to classics, and has helped put St. Ignace on the automotive world map. He was the guest of honor at the St. Ignace Car Show in 2000.

Antiques on the Bay for 2001 was privileged to have Frank Peiler, founder and publisher of *Collectible Automobile* magazine, as its guest of honor. He started tool-chasing for his father at age five. Leaning toward a career in automotive design, he shifted gears after his U.S. Air Force service and became part of the publishing business. He created *Collectible Automobile* in 1984. The show featured 1950s convertibles. (Frank Peiler.)

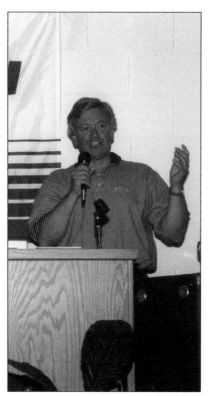

Tom Gale joined Chrysler as an engineer in 1967. He moved to design in time to work on the first generation of minivans. By 1985, he was vice president of design with Stealth, Eagle Talon, and Plymouth Laser under his direction; later hits were the Viper, LH sedan, Ram truck, Neon, Prowler, and the PT Cruiser. Tom was the St. Ignace Car Show's 2001 guest of honor. (Joe Joliet.)

Paul LeMat defined cool while playing John Milner in the 1973 cult classic *American Graffiti*. Milner ruled the streets in his yellow 1932 Ford coupe, which was voted the most famous 1932 coupe in history. *American Graffiti* was named as one of the top 100 films of all time by the American Film Institute. Paul is a decorated Vietnam veteran, recipient of two Golden Globe Awards, and a 2001 Hall of Fame North inductee. (Paul LeMat.)

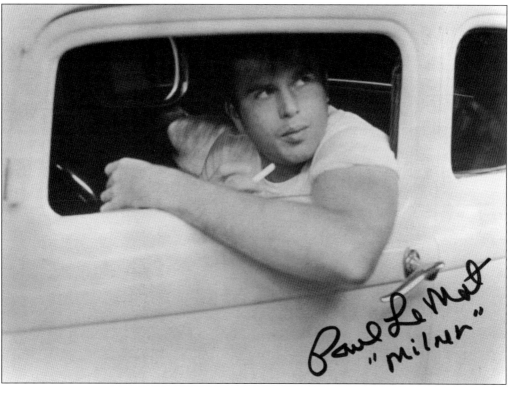

Woodies were featured at Antiques on the Bay 2002. Two hundred 1946 Mercury Sportsman woodies were manufactured in Iron Mountain, Michigan. Guest of honor Richard Kughn owns one of the remaining four. Others in Richard's museum are a 1934 Duesenberg Boattail Speedster and the 1939 Lincoln V-12 LeBaron convertible used by King George VI and Queen Elizabeth for their Royal Tour of Canada in 1939. (Richard Kughn.)

Larry Wood, the 2002 St. Ignace Car Show guest of honor, has designed more cars than anyone who ever lived. Since 1968, he has been chief designer at Hot Wheels, the Mattel Company that sells more than three million toy cars a week. He is influenced by Ed Roth and George Barris. Larry is a serious collector and hardcore automotive enthusiast. (Joe Joliet.)

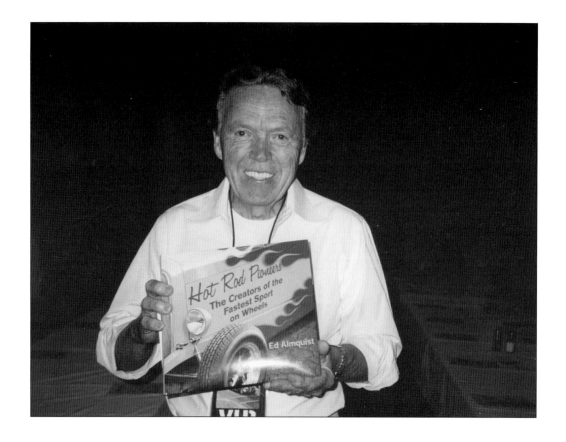

Ed Almquist published his first speed and mileage manual in 1948. He designed and manufactured speed equipment and offered it for sale through his catalogs from Pennsylvania. Almquist developed an improved spring-loaded shifter with a more compact shift pattern. Being an innovator, he was the first to offer pay-as-you-go credit; "Not a good idea," said Almquist later. In 2003, Almquist was guest of honor at the St. Ignace Car Show. After more than 50 years, Ed Reavie still has this Almquist speed equipment brochure (below) in his collection. Only 2¢ postage was required in 1953. (Above, Joe Joliet.)

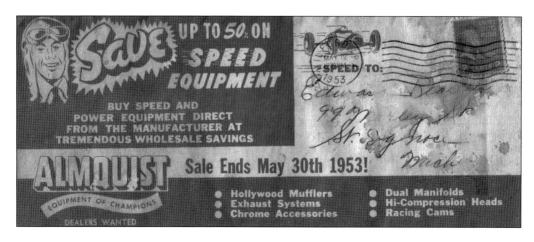

Antiques on the Bay 2003 guest of honor Jack Miller is the very last Hudson dealer. Miller Motors, in Ypsilanti's Depot Town, sells a few Hudsons each year. There are still many Hudsons around, and Miller does a good parts business. Hudson first appeared in 1909 and was manufactured until 1957. The 2003 show featured stylish 1940s convertibles of all makes. (Joe Joliet.)

Antiques on the Bay 2004 featured 1955–1957 Thunderbirds. Guest of honor "Top Hat John" Jendza III has worn many hats: author, historian, collector, host and producer of television show *Classic Car*, and voice of numerous national events. He collected his first bit of automotive history and literature (a 1950 Cadillac sales brochure) at age four and later worked the staging lanes at Detroit's Motor City Dragway. (John Jendza.)

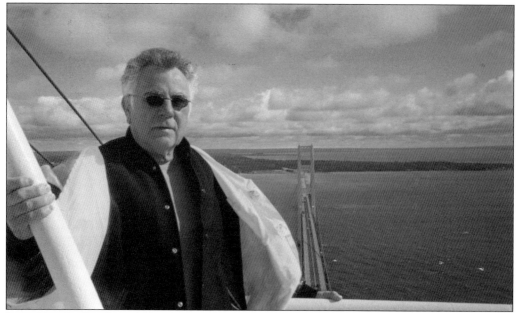

Darryl Starbird, "The Bubble Top King," celebrated 50 years in the business and was the guest of honor in 2004. His customs are done in metal, not fiberglass. Past owner of the Grand National Roadster Show, he now owns the National Rod and Custom Car Hall of Fame Museum and consults for Monogram Models. He has designed and built show rods, customs, futuristic vehicles, and street machines. (Mackinac Bridge Authority.)

Candy Clark was a co-guest of honor at the 2005 St. Ignace Car Show. Her role as Debbie Dunham in the 1973 nostalgic saga *American Graffiti* won her an Academy Award nomination as best supporting actress. The stars of this film had many other credits, but the movie really started several careers. Candy has had roles in over two-dozen films. (Candy Clark.)

Bob Tagatz has emceed the awards banquet at Antiques on the Bay since 2005. He is currently the concierge at Mackinac Island's Grand Hotel and has been the hotel's historian for 13 years. Bob knows how to enthrall an audience and gives riveting talks to visitors on the Grand Hotel's world-renowned porch. Featured, respectively, each year from 2005 were Mustangs, 30s and 40s, all 1932s, convertibles, and Mopars. (Joe Joliet.)

Born in South Carolina, Bo Hopkins went on to roles in theater productions, summer stock, television, and films. He has also produced movies. His role as Joe in *American Graffiti* is what brought him to the St. Ignace Car Show as co–guest of honor in 2005. This seminal movie about cool cars, cruising, and rock 'n' roll was set in 1962 California. (Bo Hopkins.)

St. Ignace Car Show's 2006 guests of honor were Donny Most, Anson Williams, and Cindy Williams. Most (right) was motivated to become an actor by the movie *The Jolson Story*, which he watched 50 times. He performed at Catskill Mountain resorts and in television commercials. Later, in California, he had parts in two television shows, and then came *Happy Days*. Donny auditioned for Potsie, but he won the role of the class comedian Ralph Malph. Anson's first show business roles were in stage productions, television commercials, sitcoms, and variety specials. Anson won the role of Potsie Weber on *Happy Days*, the nostalgic television comedy about a group of typical American teenagers in the 1950s—and the golden age of classic cars. Cindy played Laurie Henderson in the film *American Graffiti* and Shirley Feeney in the television sitcom *Laverne and Shirley*. Her other credits include commercials, national and regional stage play tours, Broadway musicals, television work, and over 20 films. (Joe Joliet.)

Jack "Doc" Watson has a 40-year history in developing, manufacturing, and marketing vehicle programs and products. He has operated several design, engineering, and special vehicle organizations. The 2007 St. Ignace Car Show guest of honor was part of developing exhibition cars like the "Hurst Hemi under Glass," the "Hairy Olds," and many legendary Hurst/Olds, Pontiacs, Buicks, Hemi Darts, Barracudas, and American Motors vehicles. (The Watson family.)

Roy Sjoberg created and managed the project team for the development and production of the Dodge Viper. Before joining Chrysler Corporation, he was an engineer for General Motors. Now retired, he does automotive consulting and holds domestic and international patents. He drives in Sports Car Club of America and International Motor Sports Association competitions and judges car shows. He was St. Ignace Car Show's 2008 guest of honor. (Joe Joliet.)

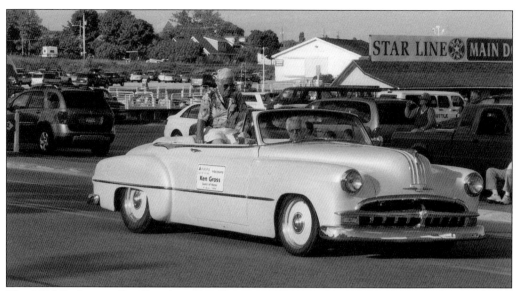

The 2009 St. Ignace Car Show's guest of honor was Ken Gross, author of the new book *The Art of the Hot Rod*. He is also a hot rod historian, car show judge, and jurist for North American Car of the Year and International Engine of the Year. He has been a museum director and consultant. Ken is a collector who favors 1930s and 1940s Fords. (Joe Joliet.)

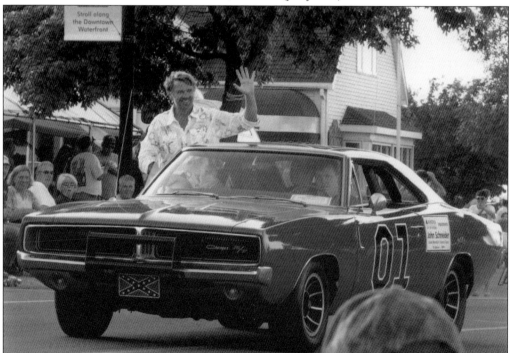

John Schneider came to St. Ignace as honorary chairman of the 2009 car show. Best known for his Bo Duke role in the television series *Dukes of Hazzard*, Schneider also had roles in more than 50 different television and film productions and a country music career. Brian Downing's (Lincoln Park, Michigan) orange 1969 Dodge Charger replica *General Lee*, complete with the famous "Dixie" horn, also visited. (Sandy Huskey.)

Five
STILL NO TRAFFIC LIGHT!

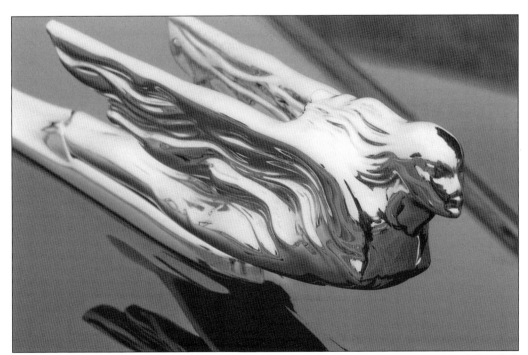

Once upon a time, most cars sported hood ornaments. They became quite ornate and detailed. Through the years, they were made smaller and plainer until now where they are virtually nonexistent. In beautiful chrome, "The Goddess" was one of the hood sculptures that adorned Cadillacs. (Joe Joliet.)

A red 1972 Chevelle, 1 of 16 past raffle vehicles (from 1991 to 2005), is ready to head to one of seven or eight shows for display during the year. The final drawing was held at St. Ignace each September. Making a last-minute check is Ed Ryan, who hauls and tends to these raffle vehicles. He and his wife, Donna, have provided vital assistance to St. Ignace Car Show vendors for many years.

The sun sparkles off the hefty chrome bumper of a 1956 Chevy Nomad. This stunning photograph shows Ed's 1955 Chevy in a miniature reflection. Sensuous chrome was a hallmark of the autos of the 1950s, although they never had too much.

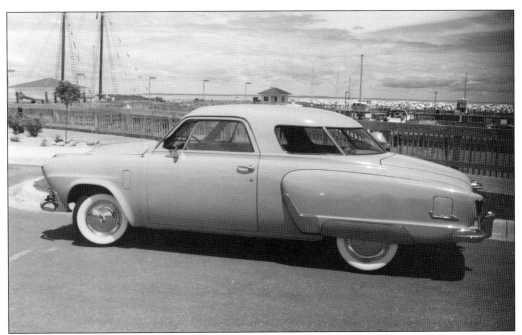

This little light-green Studebaker, a Loewy design of graceful and sprightly appearance, was very different from its peers. Raymond Loewy was not an automobile designer per se. He was a master at organizing and managing the designers who did the actual work, and he knew which ideas the public would buy. Raymond became the most famous industrial designer of his time.

An elegant DeSoto travels across the Mackinac Bridge on its way to the St. Ignace Car Show. This completely stock, burgundy convertible with tan top exhibits a sedate dignity. The skirts, wide whitewalls, and nice chrome touches give it just the right look.

General Motors' nod to the world of customized cars was the elegant 1953 Buick Skylark. This top-of-the-line white convertible with black top featured a V-8, all power, and chromium wire wheels. Plenty of chrome up front and flowing body lines make this sharp automobile a winner.

This cranberry 1956 Mercury Montclair cover girl is nosed, decked, and pinstriped fore and aft. The Appleton dual spots, custom grill, and side pipes give just the right amount of sparkle. The two-door hardtop has a louvered hood, skirts, and shaved doors and sports an angora mirror muff with fuzzy dice.

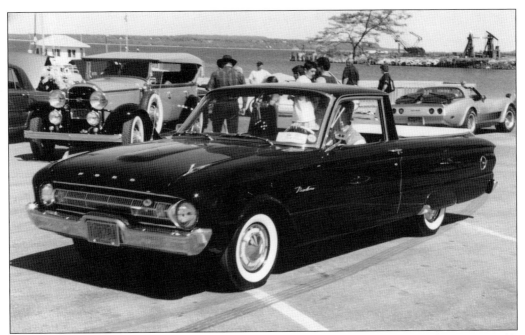

Through the 1950s, cars became bigger, fins became bigger, and chrome became bigger. By 1960, a bit of downsizing began to appear, and the small Ford Falcon made its debut. The elegant black lowered Falcon Ranchero shown here has skirts and a nice cream tonneau cover. Ford also offered a full-size version of the Ranchero, a cross between a passenger car and a pickup truck.

The 1964 Mustang is one of the most recognizable automobiles ever made. Its simple clean lines made it a triumph of engineering for Ford. An all-white paint job gives this "pony car" a nice, crisp aura.

King Midgets were manufactured from 1946 to 1970. Powered by Kohler 12-horsepower engines (9.2 horsepower after 1957), they generated incomparable fuel mileage. The crates they were shipped in became their garages. These petite two-seaters were billed as "Number One Fun Car" and "World's Most Exciting Small Car." Midget Motors Corporation in Athens, Ohio, was the sixth-biggest automobile manufacturer in the United States for some years.

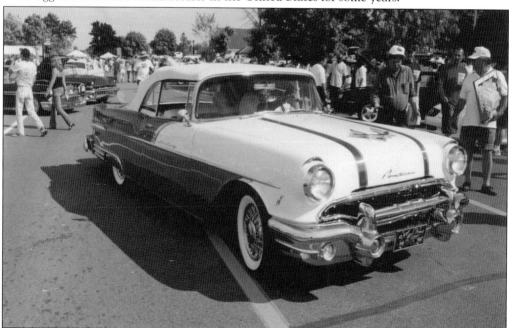

This flawless 1956 white over red Pontiac Star Chief took Best in Show at Antiques on the Bay and was invited as a feature car for the next week's big car show. It was a pure stock, V-8 convertible with all the factory options, including a Continental kit. Note the non-stock fuzzy dice. Additionally, 1956 was the next to last year for the gleaming trademark Pontiac silver streaks.

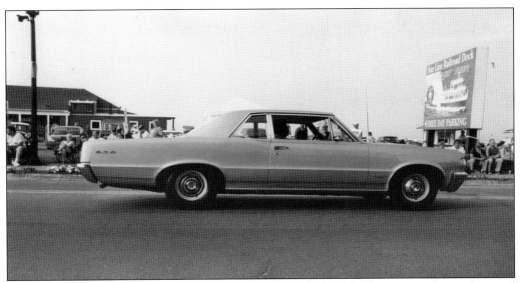

Does the photograph remind the reader of the song "Little GTO"? This car was discreetly tested on Detroit's Woodward Avenue by its creator, engineer John DeLorean. Jim Wangers marketed it through various satellite products: records, sport coats, cologne, aftershave, and cereal. The GTO transformed the auto industry.

This 1969 Cobra Mustang GT 350 was painted a luscious pumpkin gold with wide white, full-length stripes. The handsome chrome wheels give it a bit of "flash" and the functional hood scoops give a "go-fast" look. Interestingly, Hertz Rent-a-Car made a number of muscle cars available as rentals and this was one of them—note that the front license plate reads, "69 HERTZ."

The ultimate hot rod, this chopped, sectioned, and shortened 1934 Ford coupe has a custom-mixed white mint body with avocado and parchment interior and a 1950 Chevy steering wheel. In 1953, Bill Couch of Washington, Michigan, bought this Joaquin Arnett–built car and still owns it. A quick 276 flathead powers the exquisite car, which retains many stock components. This was a St. Ignace Car Show feature car.

Millions of Henry Ford's Model A vehicles were manufactured. The car show invariably attracts a fleet of them. Debuting in 1928, the Model A was durable and reasonably priced, offering an array of passenger car and truck models. Owners were starting to choose options and individualize their vehicles to suit their personalities. The rumble seat became one popular option on the two-door cars.

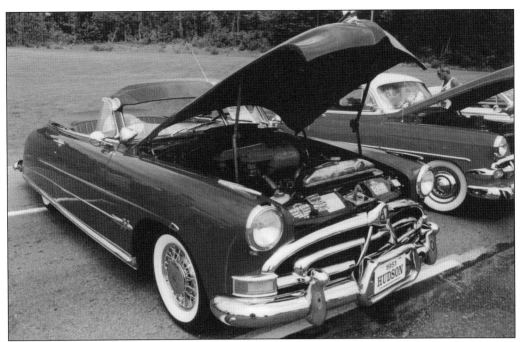

Starting in 1909, Hudson had been a pioneer with 70 auto industry firsts, including dual brakes, in-dash oil pressure and generator warning lights, and balanced crankshafts. Many Hudson innovations were years ahead of their time and eventually became industry standards. Hudsons were heavily favored by stock car racers in the early 1950s. Burgundy inside and out, this 1951 Hornet (above) provided "Twin H Power," step-down interior design, and a deep-set wood dash. With the top down, the header bar remained atop the windshield. This car also had an aftermarket sunshield. By 1954, Hudson had merged with Nash-Kelvinator to form American Motors Corporation. The AMX (below) was one of American Motors' ventures into the muscle car market. This two-seat, high-performance V-8 entry was a flawless hot red.

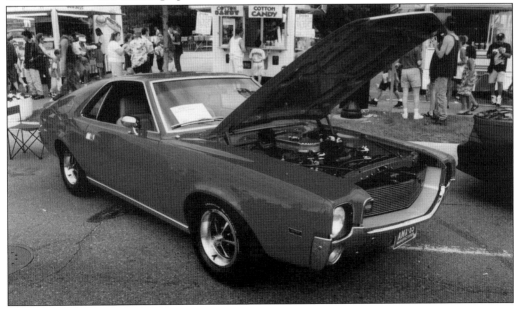

In 2009, the unusual Moxie Mobile appeared at Antiques on the Bay. The advertising vehicle had a wooden horse fixed atop a 1923 Buick chassis. It would be driven around town to promote the soft drink that claimed to cure locomoter ataxia, imbecility, loss of manhood, and more. Owner John Wissink is shown here; is he driving or riding?

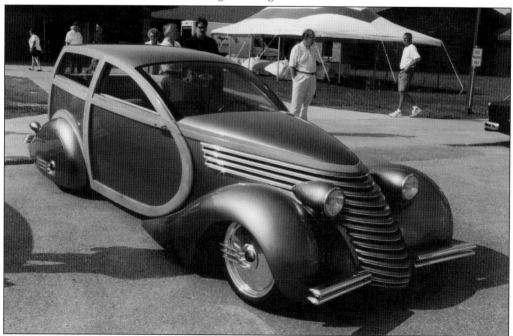

Immediately recognizable as a Posie's creation, the handcrafted *Extremeliner* is propelled by a 1993 LT1 Chevy V-8. The "long-roof" woody has a rear third door and luxurious silk headliner. Gold Razzleberry paint, a PPG Luminescence color that changes as the observer or vehicle move, creates a flawless aura for the all-steel body. Those radical futuristic wheel covers do not revolve with the tires as the car moves.

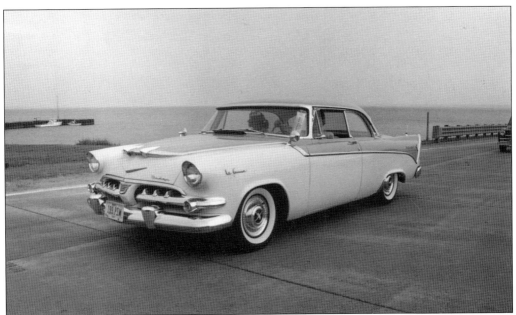

In 1955 and 1956, Dodge made a bid to attract female car buyers with its LaFemme, a $143 option package. This silky two door came in one color choice: Soft Lavender Mauve over Pale Lavender Gray with lavender interior. Also included were other amenities such as rain boots, sun visor vanity mirrors, and an umbrella with holder. Fewer than 2,500 were sold in those two years, and this pretty model was discontinued.

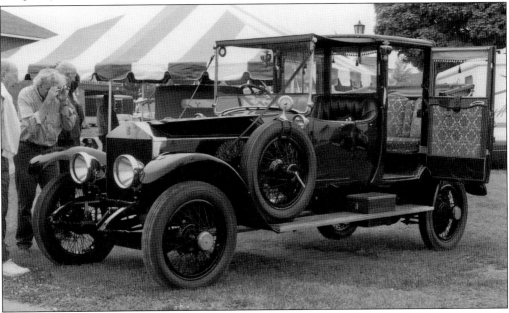

Charles Puttkammer's 1919 Rolls Royce Silver Ghost is powered by a large six-cylinder engine with a four-speed transmission. The French body's dark-green exterior paint is complemented by the original light-green, French brocade upholstery in the open rear compartment. The chauffeur's area has leather seats. This luxury automobile took the Mayor's Choice Pre–World War II Award at Antiques on the Bay 2009.

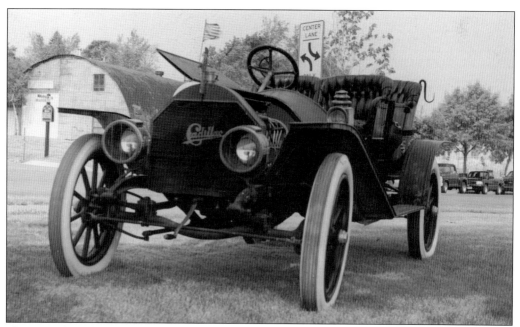

Elegant and stately, a black Cadillac awaits judging at Antiques on the Bay. The crank-start horseless carriage had right-hand steering. Brass appears on the headlight and lantern housings, radiator, and the radiator-mounted nameplate. White tires encircle black-spoke wheels, and a comfortable ride is offered by the luxurious black leather seats. Did they call it tuck and roll then?

One year, this intriguing gas station display made a showing at Dock Two. The flying red Pegasus horse of Mobil appears, along with Red Man tobacco and the Cracker Jack sailor boy (both are to the right of the right gas pump); Coca-Cola is offered in glass bottles (see bottle opener in Coke cooler); and oil is also poured from spouted glass bottles (between pumps).

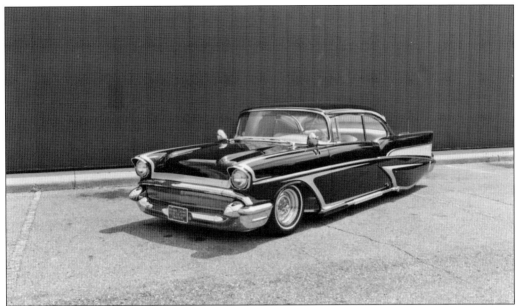

This all-Michigan custom was purchased new and still belongs to Dave Jenkins of Ypsilanti. The 1957 Chevrolet Bel Air was painted black with silver scalloping by Paul Hatton, who added the stock 1957 Buick grill. Jimmy Jones salvaged roofs of wrecks and fabricated bubble skirts from them—this car has a pair. Alexander Brothers frenched dual antennas into the front fender and then nosed, decked, and lowered this gem.

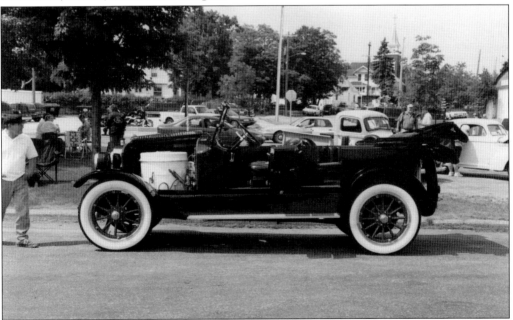

Identical twins Freelan Oscar Stanley and Francis Edgar Stanley developed the Stanley Steamer, also known as the "Flying Teapot." The steam engine had 13 moving parts, 37 in the whole automobile, and had no clutch, transmission, or driveshaft. The only sounds were the hiss of the burner and the whisper of tires on the road. The only Stanley Steamer ever at the car show was Jack Purvis's dark-blue 1919 Model 735. (Joe Joliet.)

Chief Pontiac's profile trademark appeared in Pontiac advertising, in neon at dealerships, and as a hood ornament. The chief's face, which was a bronze translucent plastic, lit up whenever the headlights were on. Also visible here are the silver streaks, a marque used by Pontiac from 1936 to 1957.

Cindy Taylor, Nostalgia Productions account executive, is enjoying the smell of burning rubber and nitro fumes at the U.S. National Drag Racing Championship in Indianapolis. Cindy has a perfect view from Parks Tower, named for NHRA founder Wally Parks.

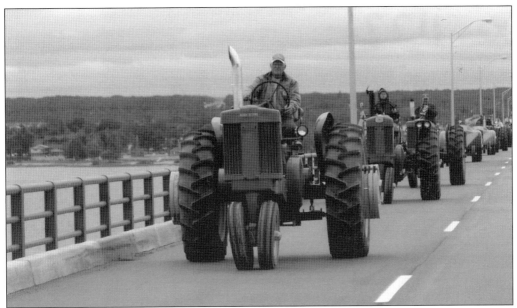

In 2008, a new spectacle was added to Nostalgia's stable of events: the Owosso Tractor Parts Antique Tractor Show. Antique farm tractors had come to St. Ignace, and on a September weekend 614 of them gathered. The highlight was that they were the first tractors to drive across the Mackinac Bridge, which was not previously allowed. They passed through town for hours. The drivers had a long trek, but everyone was smiling as spectators lined State Street to wave and cheer them on. Limited to pre-1962 machines, they varied in size, configuration, and color: gray, green, red, orange, silver, blue, and rust. In 2009, the entries increased to 811 and the bridge rally was longer. The second year, some exhibitors decided to drive their tractors north from home. About a dozen spent four days on the back roads. (Both Joe Joliet.)

Another Nostalgia Productions event is the toy pedal car show held in conjunction with the truck show each September. Shown here with Ed's 1955 Chevy is its junior replica. Because 1955 Chevies are not production toys, Christine and Kenny Brown had to fabricate the whole car, including the look-alike California license plates. This display attracted a lot of attention.

Featured as the guest of honor at the 2009 truck show was Alex Debogorski from the History Channel's *Ice Road Truckers*. Alex has been transporting cargo for about 20 years. He delivers equipment and supplies to diamond mines and experimental oil rigs via 350 miles of ice road over frozen muskeg, lakes, and rivers. The remote and subzero Alaskan and northern Canadian climate makes for harsh and unforgiving work conditions. (Bob Watson.)

The Richard Crane Memorial Truck Show in September pays tribute to the legendary trucker. He was a working trucker who customized his trucks to a degree considerably ahead of the times. In retirement, Richard (shown above in his truck, *First Class*) established the American Truck Driving School in Coldwater, Michigan. Ed created this popular show to honor his longtime friend who was an avid supporter of St. Ignace events. This show has been sanctioned by the National Association of Show Trucks since its inception in 1996. These blue and white Kenworths, though stylishly painted and shiny with chrome, are truly working tractors. The conventional (below, front) sports black and silver outlining, while the cabover tractor has red striping. All entrants are invited to participate in the Parade of Lights, a spectacular after-dark procession over the Mackinac Bridge. (Above, the Crane family; below, Joe Joliet.)

The 1940 Ford appeared during the reign of E. T. "Bob" Gregorie, Ford's chief of design. This stylish ivory all-stock convertible coupe was a feature car at St. Ignace Car Show. The other models available included station wagons, coupes, pick-ups, two- or four-door sedans, and sedan delivery trucks. The ample trunks and the very fast flathead V-8 engines made these a favorite of moonshiners.

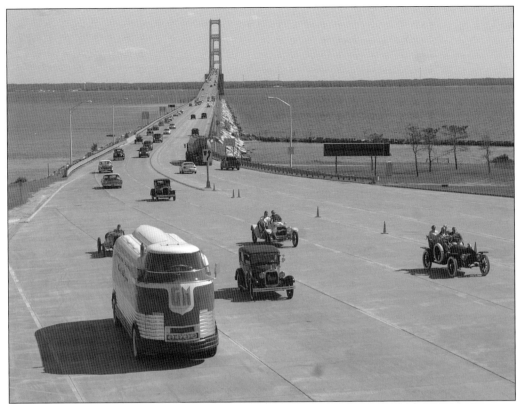

The newly restored GM Futurliner No. 10 rolls off the Mackinac Bridge. The bright red custom vehicle is almost 12 feet tall, 33 feet long, and weighs 30,000 pounds. In the 1950s, twelve of these titans traveled in a caravan called the Parade of Progress, displaying cutting-edge automotive technology to the public. One of only four still functional, No. 10 took seven years and $200,000 to rehabilitate.

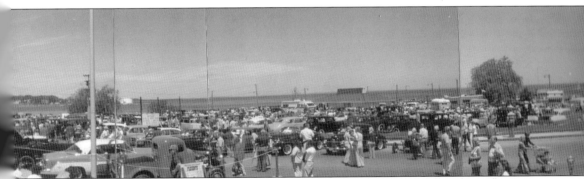

Pictured is the third-annual St. Ignace Car Show in 1978. The marina was full and overflowing into the street. Through the years, the show grew and grew until almost two miles of State Street would be closed off for the extravaganza each year. Across all those years of parades, cruises, and sunny summer car show Saturdays, St. Ignace welcomed the thousands and thousands of entry cars and trucks and hundreds of thousands of spectators. All those vehicles coming and going and still there is no traffic light in town!

www.arcadiapublishing.com

Discover books about the town where you grew up, the cities where your friends and families live, the town where your parents met, or even that retirement spot you've been dreaming about. Our Web site provides history lovers with exclusive deals, advanced notification about new titles, e-mail alerts of author events, and much more.

MADE IN THE USA

Arcadia Publishing, the leading local history publisher in the United States, is committed to making history accessible and meaningful through publishing books that celebrate and preserve the heritage of America's people and places. Consistent with our mission to preserve history on a local level, this book was printed in South Carolina on American-made paper and manufactured entirely in the United States.

This book carries the accredited Forest Stewardship Council (FSC) label and is printed on 100 percent FSC-certified paper. Products carrying the FSC label are independently certified to assure consumers that they come from forests that are managed to meet the social, economic, and ecological needs of present and future generations.

FSC
Mixed Sources
Product group from well-managed forests and other controlled sources

Cert no. SW-COC-001530
www.fsc.org
© 1996 Forest Stewardship Council

Find Your Place in History.